SCOTLAND'S WILDLIFE

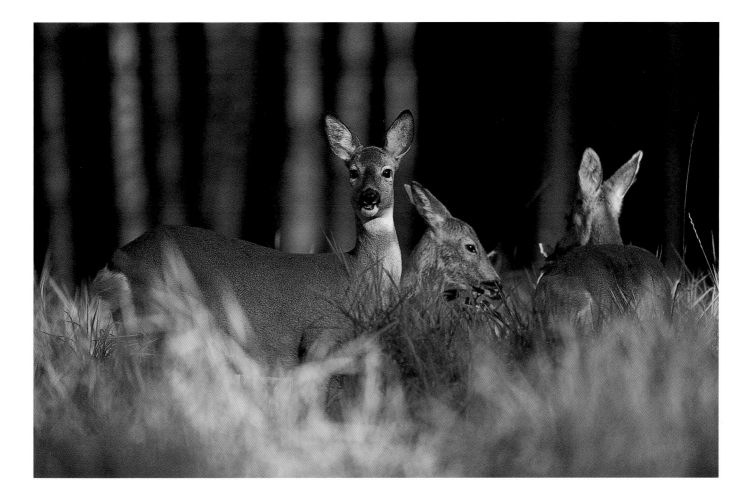

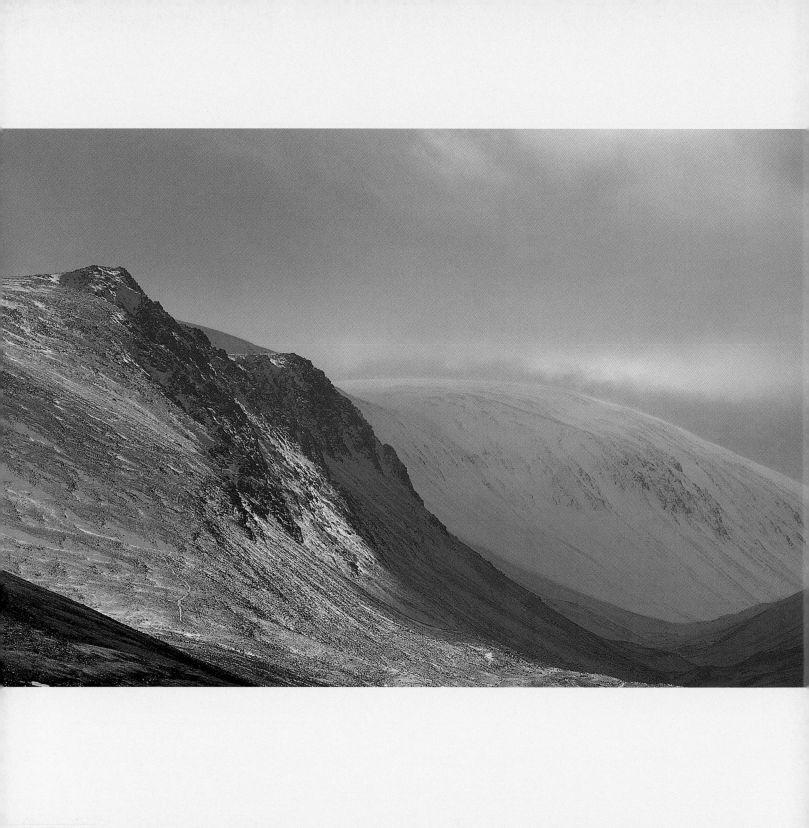

The National Trust
for Scotland

SCOTLAND'S WILDLIFE

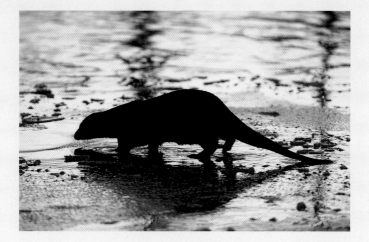

Niall Benvie

Scientific advisor Dr Duncan Halley

Aurum Press

First published in Great Britain
2004 by Aurum Press Ltd
25 Bedford Avenue, London WC1B 3AT

A catalogue record for this book is available from the British Library.

ISBN 1 85410 978 2

1 3 5 7 9 8 6 4 2
2004 2006 2008 2007 2005

Design by Eddie Ephraums

Printed in Singapore by C.S. Graphics

CONTENTS

 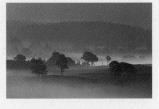

Introduction

At its heart, this book is about the relationship between people and wild nature in Scotland today. In the stories of the species I highlight, we can learn about the nature of this relationship, and gain insight into national attitudes towards the land as reflected in our treatment of it and its wildlife.

This book is also a personal record of my encounters with animals in the wild, from within that intimate space nature photographers are privileged to enter. I have spent a large part of my life in the field, initially working the land and then, for the past ten years, as an outdoor photographer and writer. A childhood passion for identification and listing has matured into a search for how best to reconcile nature and culture, led by my growing realization over the years of the grave harm we have done to the land in Scotland. Extensive travel in Latvia, Estonia and, to a lesser extent, Norway has given me a deeper sense of the meaning of landscape integrity to the extent that I sometimes find it hard now to feel content at work in my home country. Unfavourable comparisons between Scotland and other countries are all too easy to draw but, as we will see, are not always merited.

The notion of Scottish wilderness is a persistent one, propagated by photographers and tourism chiefs alike. If, however, we define 'wilderness' as sizeable areas of land able to sustain self-perpetuating natural communities, where the impact of people has always been transitory and superficial, then clearly even the wildest places fall short. So much of Scotland's natural wealth has been eroded since Mesolithic times that the landscape has long ago lost the ecological integrity required to qualify it as wilderness. Many areas, especially in the marine province, remain wild and there Nature holds the upper hand. But wilderness and culture are mutually exclusive realms, and, in a landscape settled

by modern people, we are deluding ourselves if we believe that an amicable accommodation has been reached between the two. In assuming the role of custodians of the land rather than mere citizens of the natural community, we have, over a long period, developed a profound belief that the landscape and its wildlife (as if the two were divisible) are reliant on our management input. To do nothing is seen as neglecting our responsibilities. This is expressed in the vocabulary of shame describing unmanaged land: 'wasteland', 'derelict', 'abandoned' and even, ironically, 'wilderness'. From this belief comes the concept of 'the View' – that most prized of all Scottish scenic resources – which owes its origins more to the Picturesque tradition in painting than to the realities of biogeography. Were the natural forest present,

UPLANDS

Golden eagle • Red deer • Slow worm • Wildcat
Dotterel • Hen harrier • Raven • Merlin • Peregrine
Red grouse • Ptarmigan • Mountain hare
Snow bunting • Ring ousel • Reindeer
Black grouse • Adder

improving water quality, maintaining water levels and providing nursery areas for fish in their ponds – not to mention creating opportunities for site owners to make money from beaver watching. An acute lack of imagination about how best to exploit the 'wildlife resource' too often results in particular species being dismissed as problems when they could in fact be partners. The current compensation structure, whether for lambs taken by sea eagles or grass eaten by geese, re-enforces this. This book's scientific advisor, Dr Duncan Halley, strongly advocates a change from payment for damage caused (which in his Norwegian experience of large predators is frequently exaggerated) to a system whereby farmers receive a fixed sum for each predator in the local area. This gives the farmer a motive to tolerate the 'problem' species and to maximise his profits by minimising damage. Such a policy has been in place in Sweden and Finland for a number of years and none of the interested parties, including farmers, expresses a wish to return to the discredited – and divisive – compensation model.

With such a structure in place, consideration can also be given about how best to profit from the presence of these species. In central Wales, for example, thousands of people visit Gigrin Farm each year to watch and photograph the red kites, buzzards and ravens which are attracted to bait sites established there, providing a boost to the local economy. Were an imaginative crofter to establish a similar enterprise in western Scotland where paying visitors could view sea eagles at close quarters, the birds could be seen as an asset. Similarly, beavers are a lucrative tourist attraction in, amongst other places, Denmark and the Netherlands. There is no reason to think the same wouldn't happen in Scotland. I presently have to travel to Norway or the Baltic States to get such opportunities. Already one or two small-scale eco-tourism operators have realized the potential of providing wildlife experiences by leaving bait for pine martens, red squirrels and crested tits and establishing permanent hides at black grouse leks (display grounds). Interestingly, these initiatives are often led by people coming from elsewhere to settle in the Highlands, bringing with them a greater awareness of the general interest in Highland wildlife – and potential to make a living from it – than is sometimes appreciated by local inhabitants.

Though some parts of this book might make for rather gloomy reading, there is much to feel positive about. Never before has Scottish wildlife had such powerful allies in the shape of non-governmental organizations such as The National Trust for Scotland, the RSPB, the Scottish Wildlife Trust, the Woodland Trust, WWF Scotland and the John Muir Trust. Even the government-founded Forestry Enterprise has changed its primary remit from producing a strategic reserve of timber to conserving wildlife. Many farmers have taken up government-funded initiatives to plant farm woodlands and other major reforesting projects are taking place the length and breadth of the country. A new generation of well-travelled and broad-minded young farmers, crofters, foresters, wildlife conservationists and other land managers are having a say about how things should be done. The Scottish Parliament is more accessible and better able to act upon a public desire for change than Westminster. Already, Scotland leads the rest of Britain on access legislation as well as a host of other environmental measures, including controversial ones relating to fox hunting, which the UK Parliament seems destined never to address conclusively.

Finding a fair accommodation between the needs of 21st-century people and wild nature is something we have never achieved and remains the greatest challenge to this nation of leaders and inventors. The subtleties of meaning in the Scots language are profound, yet too often we find ourselves tongue-tied in dialogue with the wild nature of our own country. We have grown too used to telling the land what we will take from it rather than listening to what it is offering. This book, then, should be seen as a call to action rather than a charter of despair.

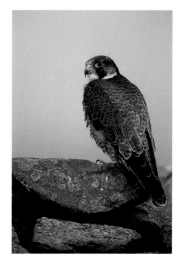

never know what we will need from the land in future; it is better to start again with a fully stocked store. But we have always wanted more than the land can give. Our need in the 18th century for Highland timber was greater than our need for the boreal forest. Some soils, pushed too hard for too many years, have lost much of their organic matter and now require intensive, fuel-hungry cultivation and inorganic fertilisers to yield heavy crops. The 'forest in waiting' in these fields has long since given up. Not only has wilderness been superseded by culture but wildness, the essential character of the land, has been damaged too; the store of natural capital has been raided and we are the poorer for it. The beaver and the lynx will never return unaided.

A dark side of the national character, I believe, is revealed in the attitude towards recovering species, mirroring feelings sometimes expressed towards successful people who 'get above themselves'. Species extinction has been going on apace in Scotland since the end of the last Ice Age – and before. Sometimes, in the case of reindeer, collared lemming and wild horse, climate change was a major factor. Others have disappeared because of people. In some cases, extinction came about when habitat was lost to agriculture or industry or when there was ignorance of

ecologically sound harvesting principles. But other species, such as the sea eagle, osprey and wolf, were systematically eradicated. Many other predators were heavily persecuted by Victorian and Edwardian game managers and then, in the early stages of recovery, debilitated by inorganic chemicals insinuated in the food chain. Only recently have we witnessed the resurgence of buzzards, pine martens, sparrowhawks and sea eagles (although in the latter's case, this has been as a direct result of a re-establishment programme). Sadly, it seems that whenever a species that was once endangered makes a conspicuous recovery, public sympathy for it quickly ebbs and questions begin to be asked about the need for control – sometimes with little regard to the relationship between predator and prey. The peregrine is vilified by some as a major killer of domesticated racing pigeons released into the wild; poultry keepers bemoan the intrusion of pine martens into ill-secured coops; and sea eagle predation of lambs is seen as a problem that could have been avoided if they hadn't been brought back in the first place. In light of this deep-seated meanness of spirit towards other species whose rights to full citizenship are as strong as ours, the political foot-dragging over the European beaver re-establishment programme comes as no surprise.

In spite of strong public support expressed in 1998 in a consultation commissioned by Scottish Natural Heritage, at the time of writing (October 2003) not even the trial phase of a re-establishment programme, let alone a full-scale re-introduction, has begun. In December 2002 the Deputy Environment Minister decided not to issue an import licence to enable the trial to begin, citing the need for more research into the possible effects on farming, fisheries and forestry. But a vast literature on these very issues already exists – so far there have been 157 fully documented reintroductions elsewhere in Europe and just about every country formerly occupied by the beaver has re-introduced it, including the densely populated Netherlands and Denmark. The reasoning of those who oppose the beaver's return seems suspect.

The fact is that the beaver, more completely than any other European mammal, challenges our primacy as landscape managers. Beavers can and do alter local landscapes, in certain conditions, over quite a large area. But to look at this fact in isolation is to ignore the benefits they bring, which include

we would not have the vast monocultures of heather – which is naturally an understorey shrub – or the uninterrupted vistas over kilometres of denuded valleys. Yet these are what many people come to Scotland to look at and they continue to be celebrated in Scottish landscape photography.

Our active management of the landscape is inevitably guided by relatively short-term objectives, goals that change over decades and centuries with the economic situation and social attitudes. Who would have thought in the hungry 1940s and 1950s that by the start of the 21st century farmland in Britain would be converted into woodland and productive fields left fallow? How many people in medieval Scotland cared about the demise of the beaver? Perhaps in 20 years time, pouring large amounts of money into saving marginal Scottish populations of, say, corncrake, will be seen in retrospect as a waste of resources when core populations under threat in Eastern and Baltic Europe – in countries that are now economic and political partners – received scant attention and little funding.

The view that management of the countryside is best left to those living there remains widely accepted. For many country people, the land is a shop floor, not a sanctuary, and management decisions are based on the need to get a living rather than sentiment. That is understandable but it does mean that in terms of economic aspirations, there is little difference between town and country in the UK. To say that 'conservation must pay' misses the point, demonstrating an attitude to the land little different from the majority of townspeople: it is seen as something there to be used to achieve other ends. Such expressions do not suggest a belief in the value of landscapes for their own sake, only for their economic (or spiritually recuperative) potential. Before my career as a photographer and writer, I was a farmer and know first-hand the hollowness of the claims of some who argue that because they live in the countryside and support their families from it, they necessarily understand it better than townspeople and therefore have its best interests at heart. In my experience, relatively few of the more vociferous 'custodians' can even identify common birds, insects and plants. How then can they properly claim to

understand the complexity of entire ecosystems and to possess an insight into their needs? Their appreciation and economic understanding relates to a landscape of their own creation rather than the richness, spontaneity and unpredictability of a wild one. The two camps, of town and country, are in fact much closer than is often acknowledged.

At the opposite pole is a management strategy focused on ideals of wilderness. I believe that this model is equally unhelpful, since it does not allow for the possibility of a meaningful co-existence between people and the land. In exercising self-restraint, we make ourselves outsiders, consumers of scenery and wildlife encounters rather than harvesters of food, fish and forest products. In the long run, economic reliance rather than aesthetic appreciation provides a more compelling reason to conserve. The trouble is that in Scotland we have never been able to strike a fair balance. The fundamental moral obligation on all land managers is to preserve the potential for wild nature to regenerate of its own accord. They should do this, if for no other reason, because we

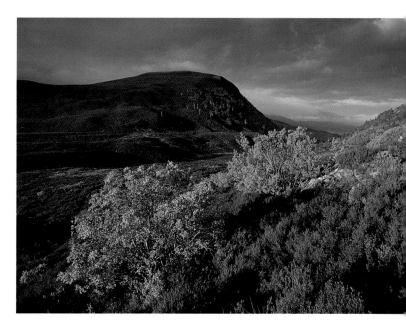

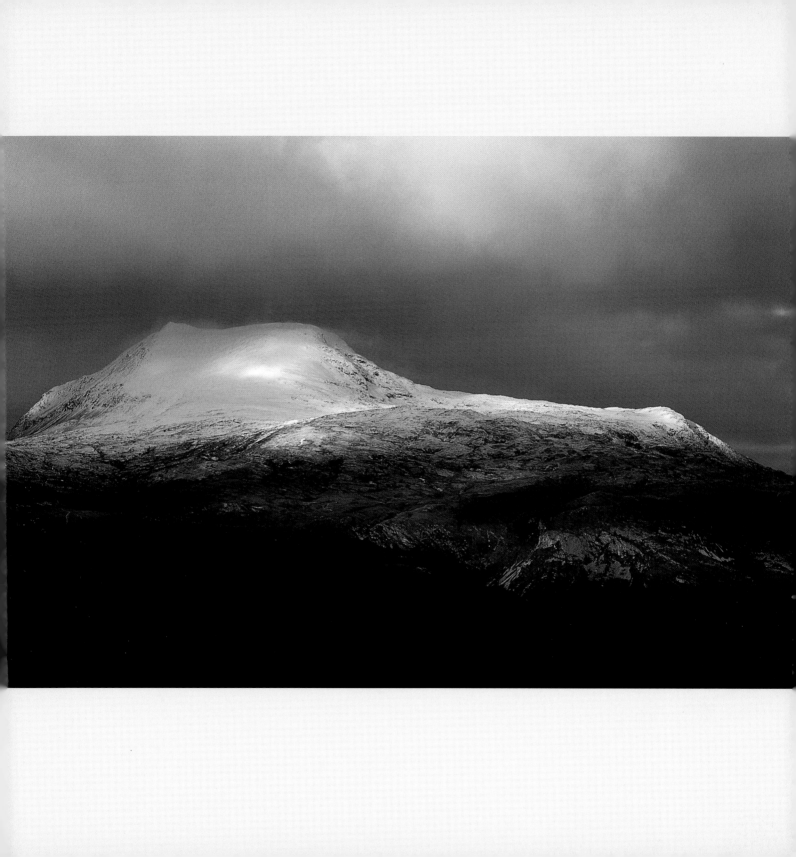

Golden eagle

Regardless of their totemic status, persecution continues to inhibit the spread of golden eagles into some part of the Highlands.

The golden eagle is the most widely distributed of the true eagles, with a range across the entire Northern hemisphere, but we nevertheless value this bird more than any other as emblematic of wild Scotland. Shunning human settlement, eagles nest on crags (and occasionally in 'granny pines') in mountainous areas up to almost 900 metres, as well as on remote sea cliffs. Increased recreational use of the hills, initially for sport shooting and latterly for walking and climbing, has brought ever more people into eagle country. In one Angus glen, an eyrie was situated close to a site for the very rare yellow oxytropis which, with the upsurge of interest in alpine flora in the 1980s, attracted a steady stream of plant hunters, too close for comfort. For the sake of the eagles, Scottish Natural Heritage has found it necessary to discourage visits to the plant.

In western Scotland there is considerable overlap with sea eagles in respect of diet (principally rabbits and sheep carrion) and nest sites but the greater abundance and diversity of food and choice of tree nest sites in central, coastal Norway means that the two species occupy different niches. There, golden eagles concentrate more on live hares, ptarmigan and other terrestrial prey and nest mainly on cliffs whereas sea eagles take most of their prey from or by the sea and prefer to nest in trees. But in winter, especially when the clouds are down or the snow deep, both species readily exploit carrion, especially younger birds which have yet to refine their hunting skills. In character the two birds are quite different; there are reliable reports of one golden eagle displacing seven sea eagles from a carcass and scant evidence of sea eagles ever holding their place. I have witnessed three being shifted by a single golden eagle.

Regardless of their totemic status, persecution continues to inhibit the spread of golden eagles into some part of the Highlands. Particularly distressing are cases involving birds that have received intensive volunteer protection. While much of the Scottish countryside was effectively off-limits during the foot-and-mouth disease outbreak in 2001, egg thieves struck two unguarded nests in the Trossachs. Another eyrie near Alloa, which had been targeted by criminals for eight years and given 24-hour protection by local volunteers and conservation staff for the previous five, finally fledged an eagle in 1999, only for it to be found poisoned the following year on a moor near Loch Tay. Whether poison-laced carcasses are targeted at crows, foxes or birds of prey, their use is illegal and indiscriminate. Such practices shame all those involved in game and livestock management who actively or passively condone them.

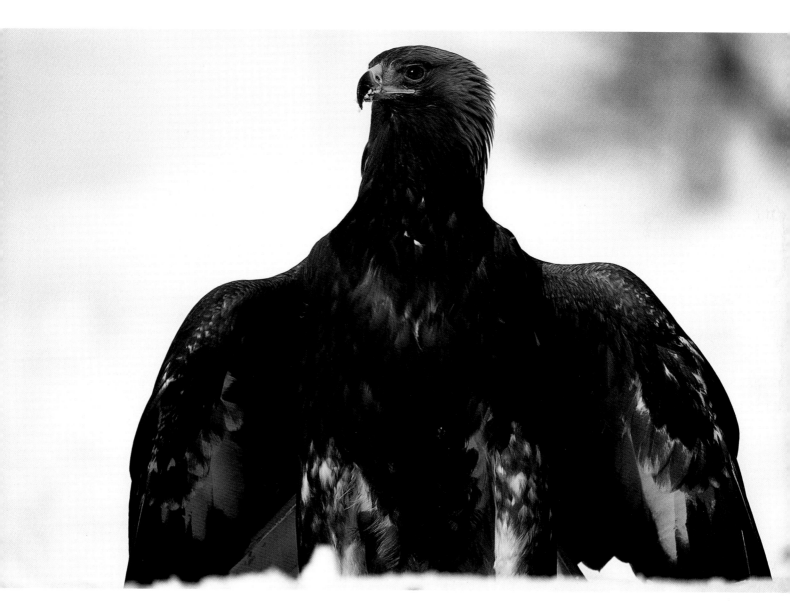

Red deer

'Deer forest' in the Highlands is synonymous with open space. With the ascendancy of the sporting estate following the Highland Clearances in the 18th century, red deer acquired a new economic worth, one reflected to this day when reckoning the value of estates.

Set alongside its continental cousins, the Highland stag is a rather weedy-looking beast. Its smaller body and thinner antlers are the result of living for generations on the open hill rather than in a well-provisioned broad-leaved forest. 'Deer forest' in the Highlands is synonymous with open space. Nevertheless, for most visitors the red deer embodies the spirit of the Highlands. Some conservationists, in contrast, demonise the red deer, citing its high numbers as the primary cause of poor regeneration in the old pine forests. Sometimes it is even spoken of as if it were a species of 'vermin'. We would do well to reflect on our own role in the current state of affairs and consider the future of this icon of the Scottish Highlands as it forges an alliance with the introduced sika deer (see p. 46).

The many red deer that winter in valley pine woods undoubtedly eat lots of pine seedlings but the forests' lack of vitality is not the deer's fault alone. In the absence of wild boar or cattle to break up the forest floor, a dense layer of mor humus, created by fallen pine needles, accumulates, making it hard for pine seedlings to reach the mineral soil below. And thanks to the strict control of forest fires, this layer just keeps on accumulating. Seedling establishment is lower than in comparable, boar-free, forests in Norway where deer densities

are lower. Having extinguished the red deer's chief predator, the wolf, we've taken its role upon ourselves without appreciating that predator numbers are regulated by prey not vice versa. The result is a hopeless failure to maintain numbers commensurate with the ability of the land to sustain them (there are currently about 400,000 red and red/sika hybrid deer), with the inevitable depressive effects on natural vegetation. With the ascendancy of the sporting estate following the Highland Clearances in the 18th century, red deer acquired a new economic worth, one reflected to this day when reckoning the value of estates. Given the deer's monetary value to landowners, the latter are unwilling to kill up to 80% of the herd (as has been suggested for one large west-coast estate) to encourage natural forest to regenerate. With our help the deer has prospered; it is hardly the architect of the problems it is causing.

When deer are shot they are traditionally gutted on the hill and the viscera, or gralloch, is left to scavengers ranging from stoats to golden eagles. Any moves to stop this practice on the grounds of environmental health and require gralloch to be buried on the spot would inevitably have knock-on effects on a range of species and diminish the deer's direct contribution to the economy of the hill.

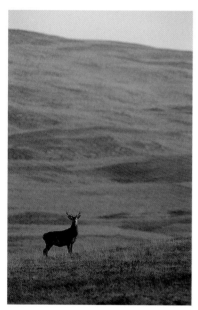
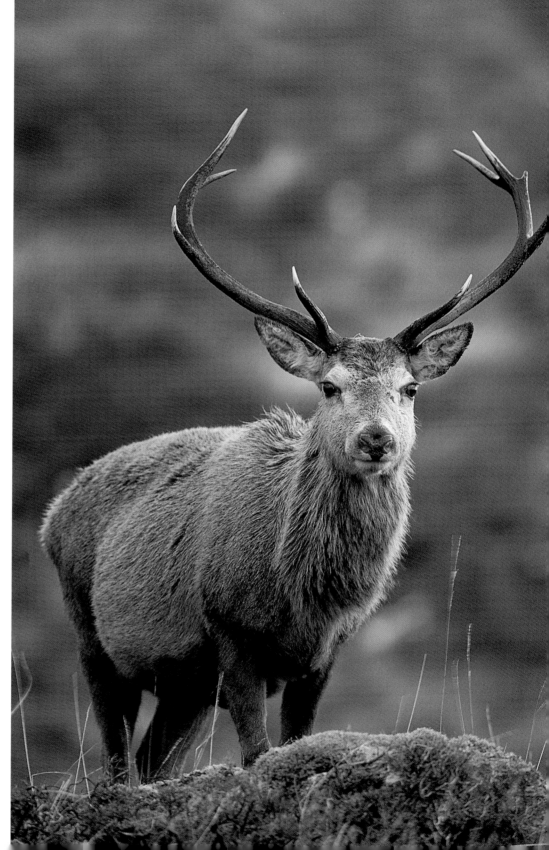

Slow worm

The slow worm's snake-like appearance means that it is a 'collateral casualty' in the general hysteria that persists against adders.

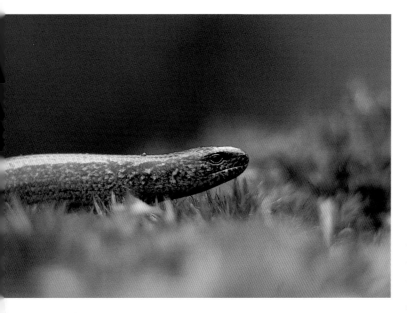

The inappropriately named slow worm is one of only three species of reptile native to Scotland. It shares with other lizards the ability to shed its tail (which can regenerate) when grabbed by a predator, although unlike its relatives the slow worm is legless. Close inspection reveals that the body is pinched in about two-thirds along its length, marking the start of the tail.

The slow worm's retiring habits and preference for basking in cover, rather than in the open as adders do, mean that the animal is often overlooked. The best chance of seeing one is by checking under sheets of corrugated iron, particularly in the uplands. The iron not only provides security from attack but heats the ground under it on a sunny day. Like other animals unable to regulate their body temperature internally, the slow worm is inactive in cold weather but equally cannot tolerate prolonged exposure to hot sunshine. Life in the slow lane also involves hibernation, often in a large huddle with other slow worms. This happens between October and March, the exact times depending upon weather conditions. When they emerge from their subterranean lairs to the first spring sunshine, males compete for females in jousts which involve a lot of twisting and biting. The sexes are distinguished by the female's brown colouration and dark stripe along the middle of the back; males are more silver-grey, older ones sometimes having blue spots behind the head.

This reptile has been an unexpected beneficiary of the eradication of rats on Ailsa Craig (see p. 68) and, thanks to reduced predation, some specimens now grow as long as 50cm. The slow worm's snake-like appearance means that it is a 'collateral casualty' in the general hysteria that persists against adders and other snakes, but one close look at its sad little face should be enough to soften most hearts.

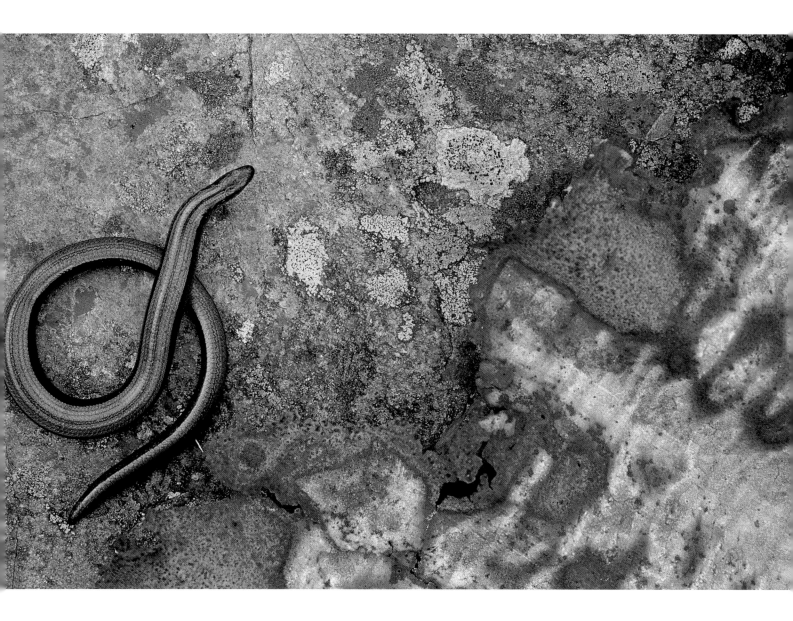

Wildcat

The wildcat and its environment provide their own defence against 'dilution'.

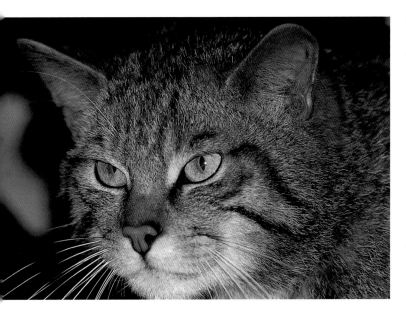

The Victorian and Edwardian passion for 'predator control' affected the wildcat as severely as any of our other native carnivores. The First World War brought the species relief as gamekeepers were sent to the front; many didn't return. The social upheaval following the war extended to the top of society; the officer class had not been immune from the slaughter and many estates were now broken up to pay death duties. The halcyon days of the great sporting estate were over and the wildcat had a chance to rebuild its numbers.

The fear is often expressed today that interbreeding with feral domesticated cats will lead to the genetic extinction of 'pure' wildcats. There is cause to be concerned, certainly, but not for this reason. Quite simply, natural selection weeds out the domesticated cat's genes very quickly. Were this not the case, the wildcat population would rapidly become indistinguishable from domesticated cats – something that would have happened before now given the long association between wild and domesticated cats. The latter is ill-adapted to life in the wild in the Scotland and the selective pressures are against it. The wildcat and its environment provide their own defence against 'dilution'.

In a legal sense, however, definitions of purity matter. There has yet to be a successful prosecution for killing a wildcat, simply because the Wildlife and Countryside Act protects 'pure' species, not hybrids. Even if the animal has all the features of a wildcat, it is very hard for the prosecution to prove that there are no 'foreign' genes present, that the animal is not a hybrid. To complicate matters further, the type specimen against which all future wildcats would be judged was not collected until 1907, by which time such a judgement was arbitrary, in view of the long preceding history of cross-breeding. Without a broadening of the definition of wildcat and protection of animals that can't visually be distinguished from wildcats, the law will continue to offer little protection from persecution.

Dotterel

Females sometimes breed with more than one male in the same season, seeking a different mate and laying a second clutch just five to ten days after the first.

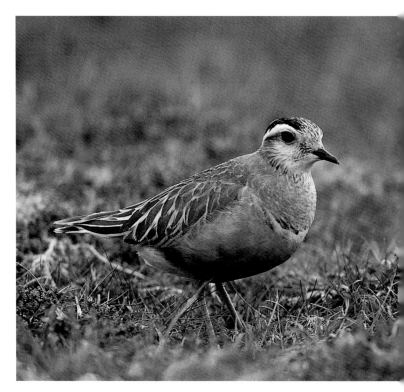

A walk on a high stony plateau in the eastern Highlands in spring always holds the exciting prospect of encountering a trip of dotterel. Some will stay to nest, while others are en route to territories in southern Norway and beyond. The Victorian love affair with skin and egg collecting claimed the dotterel as one of its many victims and caused a widespread decline. The feathers were particularly valued by fly-tiers, who used them on wet fly patterns to represent wings and hackles.

Protected status helped the population to recover though figures from 2002 showed a 23% decline in the number of males since 1987/88 to 630. Rather like those other refugees of the high tops, the snow bunting and ptarmigan, dotterel are vulnerable to subtle climatic change which affects the character of their habitat, especially if it increases competition for food.

It's not hard to see why the dotterel was sought after by Victorian collectors; the subtle buffs of its back and richer chestnut of the belly are set off by a brilliant white crescent suspended across its chest and another arching over its eye. Unusually, it is the female who wears the brighter plumage and the less showy male is responsible for incubation and care of the chicks – hence the survey counting males alone. In Britain, only the dotterel and red-necked phalarope practise this reversal of roles. Females sometimes breed with more than one male in the same season, seeking a different mate and laying a second clutch just five to ten days after the first. There is also a record of a female having mates in Scotland and southern Norway in the same season.

While dotterel can appear to be tame – the name implies naive trust – it is best to steer clear of the whaleback ridges where they nest in June. As more walkers venture into the hills crows are attracted up from the valleys by any scraps of food left behind – and will take advantage of any unguarded nests while they are there.

© Neil McIntyre

Hen harrier

The real problem for both grouse and harriers is the declining quality of heather moorland as EU payments have encouraged overstocking with sheep.

In recent years, this elegant moorland hunter has been at the centre of heated debate over its predation of red grouse. Grouse are economically important for many estates and any predatory pressure is looked on gravely, so much so that hen harriers in some parts of Scotland are still actively – and illegally – persecuted. There is no doubt that hen harriers do target red grouse when they are available: the six-year study undertaken by the Institute for Terrestrial Ecology on the Langholm Estate in south-west Scotland found that between them, peregrines and hen harriers killed an average of 30% of the potential breeding adult population each spring and up to 37% of the current year's chicks. Taken out of context the numbers seem high, and the findings have been claimed as evidence that these predators prevent the grouse population from recovering. It is equally easy for conservationists to pin the low density of hen harriers in some areas on the activities of keepers.

Scratch beneath the statistics and rhetoric and it soon becomes evident that the real problem for both grouse and harriers is the declining quality of heather moorland as EU payments have encouraged overstocking with sheep. On Orkney, there is no recent history of harrier persecution yet the population shrank by 70% in the last quarter of the 20th century. Overgrazing depresses the growth of heather and means that moorlands become dominated by grass. Both harriers and grouse favour deep heather to nest in but harriers use adjacent grassland to hunt birds and small mammals which are found at higher densities there. Grouse, in contrast, prefer short, young heather to feed amongst. Too little heather is bad for both species. Healthy populations of grouse in sympathetically managed habitat can support high densities of predators and the impression of raptor populations growing at the expense of the prey can only ever be a short-lived one as readjustment takes place. The Langholm report also noted that a long-term decline in the size of grouse bags had been going on well before protection enabled raptor numbers to grow. This was linked to the loss of prime grouse habitat.

A short-term compromise has been reached between pro- and anti-control camps thanks to the willingness of harriers to visit 'diversionary feeding' stations. Trials have shown that harriers on grouse moors will preferentially take one-day-old chicks provided by game managers to feed their broods, greatly reducing predation on grouse. The job of moorland restoration, however, is a much more complicated and long-term task.

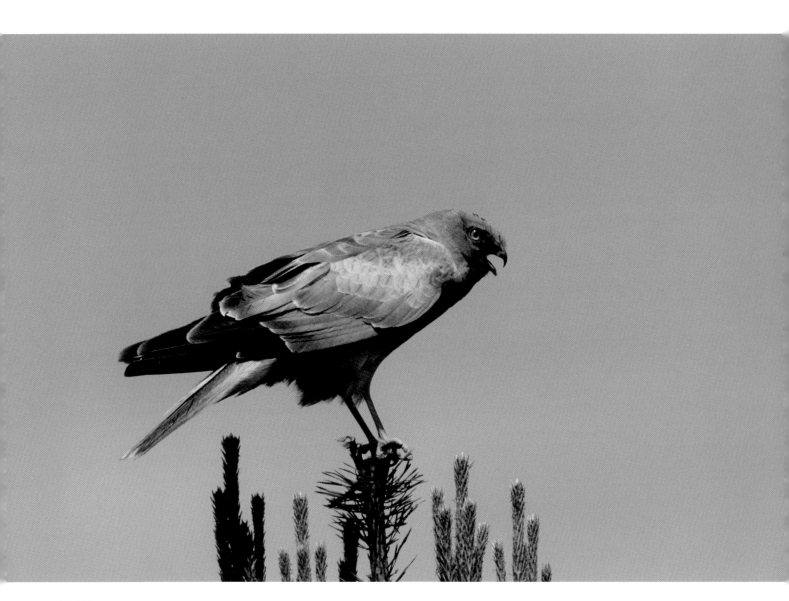

Raven

Only once the ravens had overcome their reserve did eagles dignify the throng.

If you hope to get a golden eagle to come to a carcass, you must first gain the trust of the raven. Eagles are not as wily as ravens but they are smart enough to know that when a raven sees fit to descend to a carcass, then it really is safe. On my first visit to photograph sea and golden eagles in Norway I had to wait six days to gain the confidence of a pair of ravens that watched over the bait site. As black and shiny as anthracite, they perched near my hide like a pair of crones, looking on with hard eyes, reluctant to join the grey and black mêlée of hooded crows already feeding. Only once the ravens had overcome their reserve did eagles dignify the throng.

On another occasion, this time in eastern Latvia, I waited in a forest house for five days for wolves to visit a bait site, keeping the lights off during the moonless March nights to minimise disturbance. Here the ravens were less wary – the house owner had not shot them for years – but nevertheless, there was always one perched in the pre-dawn gloom by the opening where my lens looked out. And early each morning, it quietly 'quiff-quiff-quiff'ed away to tell the others that I had taken up position.

While the raven is typically a bird of the forest in many parts of Europe, British ravens, numbering about 7500 breeding pairs, are much more associated with mountains and remote sea coasts. Numerous ancient cultures, particularly in North America and Scandinavia, projected human characteristics onto the raven in their narratives, and European mythology, in particular, emphasizes the raven's role as a messenger. Sometimes, as in the case of Odin, the raven is the manifestation of a god or spirit, a shape-shifter. But by the mid-19th century, when the Scottish sporting estate began to flourish, the raven had long since ceased to be an object of wonder. Persecution (or control) of actual and potential predators was an important feature of upland management for a long time and remains so. This has made the carrion-feeding raven cautious and reclusive, and it retires to inaccessible cliffs to nest. The nesting season begins early, which enables chick rearing to coincide with the peak supply of winter-killed carrion.

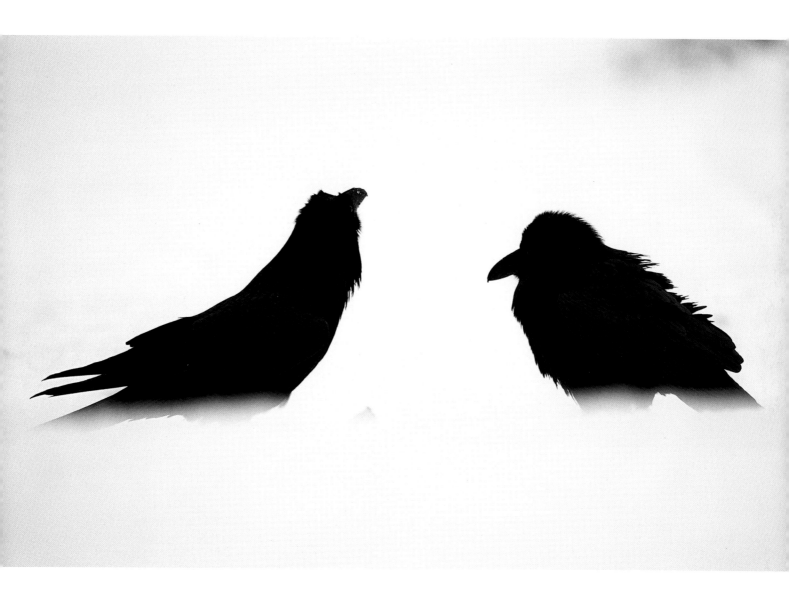

Merlin

Amongst the falcons, only the hobby can match the merlin's agility.

I was watching a group of swallows hunting insects on a warm September afternoon above the moor. The heather was rapidly fading; the rabbit cropped turf crisp with drought. Without warning there was a commotion amongst the swallows and from their midst shot a falcon no bigger than a mistle thrush. It wasn't possible to see if the bird the merlin held in its talons was a swallow or some other victim caught earlier but the sense of panic amongst the swallows was palpable. On their moorland nesting territories, meadow pipits are the merlin's main prey species but on migration they have been recorded hunting swallows, starlings and skylarks. Amongst the falcons, only the hobby can match the merlin's agility.

Like the hobby, the merlin is migratory, though over much shorter distances. Scottish birds move down to the coast in winter where they are joined by others from the Faroes, Iceland and Norway. In the saltmarshes and estuaries, waders up to the size of lapwings are on the menu. Roughly 1300 pairs of merlin nest in Britain, mainly on upland moors. Here, they occasionally take very small grouse chicks but these are minor food items and conflict with sporting interests is less acute than in the case of hen harriers or peregrines. Pesticide contamination in the 1950s and 1960s, which increased mortality by thinning egg shells, has taken a long time to work its way out of the merlin population and it remains the most heavily contaminated raptor in the UK, especially in respect of mercury. The main cause of local declines nowadays seems to be the change from heather moor to grassland, affecting the prey resource as well as nesting opportunities. A number of pairs have taken to life on the fringes of plantations quite successfully.

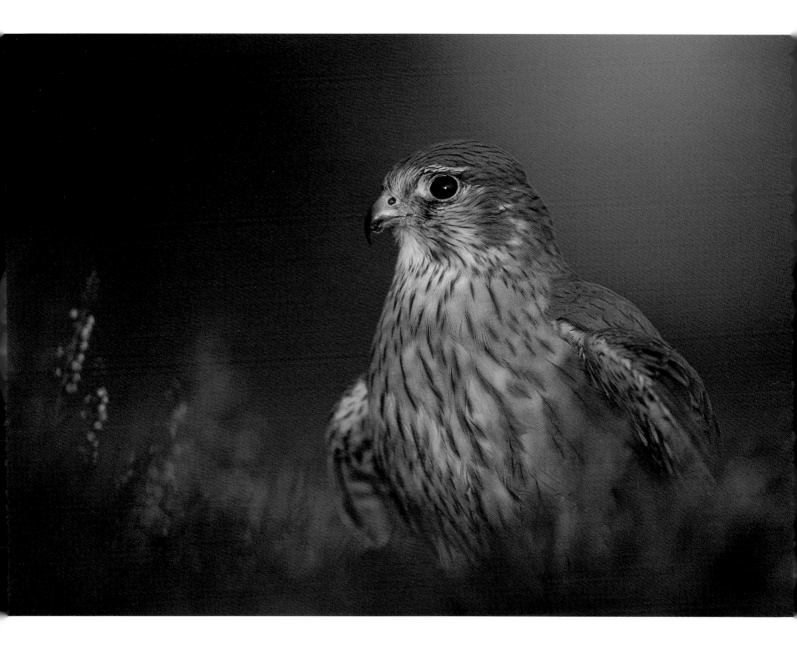

Peregrine

Success has brought with it calls to control their numbers, most notably from the homing pigeon fraternity.

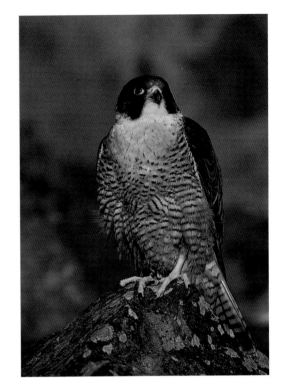

It can be tough at the top of the food chain, as the peregrine showed in the 1950s when accumulated organochlorine pesticides reached fatal concentrations in its prey. Those that survived produced thin-shelled eggs or were infertile. Even although the use of these chemicals began to be restricted in the 1960s when the problem was recognized, recovery to pre-1930s levels has taken much longer. In 2002, however, 1402 pairs bred in the UK, exceeding previous recorded highs. In a pattern familiar with other recovering predators, success has brought with it calls to control their numbers, most notably from the homing pigeon fraternity. As well as the moral issue around whether a wild bird should be killed to protect a domesticated one released temporarily into the wild for sport, the actual level of pigeon mortality attributable to peregrines is hotly disputed between fanciers and conservationists. What is certain is that there are many ways pigeons can be killed during a race – the most common being collision and straying – and the peregrine, whatever the real extent of its impact, is simply responding to an abundant food source.

The pattern of the peregrine's recolonisation is not uniform. During the 1990s it declined by 30% in the Highlands and Argyll – perhaps more because of poor food availability than persecution – and disappeared altogether from the Shetlands. Here, conflict with the expanded population of fulmars has been blamed; the petrels disgorge oil onto cliff-nesting peregrines making flight almost impossible. In contrast, the falcon is now more common in southern Scotland and it occupies parts of England where it was previously unknown. Peregrines have shown themselves willing to forsake wild areas and move into the lowlands. Many former coastal nest sites (excepting Shetland) are now reoccupied and peregrines regularly use man-made structures including power stations, bridges and quarries. In the middle of Montrose a few years ago, one regularly roosted on the Old Kirk's spire, littering the pavement below with dismembered quarry taken from the nearby Basin.

A number of nest sites, including those at the Falls of Clyde (Scottish Wildlife Trust) and The National Trust for Scotland's Grey Mare's Tail, have a CCTV link allowing thousands of people each year to see the birds in close up. This level of surveillance is also a major deterrent to egg thieves.

Red grouse

As the rail network opened up the Highlands in the late 19th century, so it became possible for many more people to come from the south to join shooting parties on moors specially managed for red grouse.

The development of the sporting estate after the mid-1800s was driven in part by the emergence of a new class whose wealth was derived from commerce rather than inheritance. It had money to spend on leisure – and to buy and manage estates for game. As the rail network opened up the Highlands in the late 19th century, so it became possible for many more people to come from the south to join shooting parties on moors specially managed for red grouse. Strips of heather were burned in the autumn to create a variety of ages, deep heather for nesting cover alternating with strips of fresh, nutrient-rich growth where the birds could feed on new shoots. Predators were, if possible, eradicated and displayed on 'gibbets' to demonstrate the keeper's prowess. Game bags in Victorian and Edwardian Scotland were probably about as big as they could possibly be.

The long-term decline in grouse numbers began in the 1930s – way before birds of prey began to recover from persecution by egg collectors and keepers. This, in part, is related to the loss of high-quality moorland to grass as sheep densities have increased. The problem is exacerbated by the practice of muirburn – moor burning – which, while it provides short-term gains in terms of heather productivity, in the long run encourages the succession of heather by grass, particularly in wetter areas. Over a shorter time period, red grouse numbers are highly cyclical – in Britain, this cycle is complete in about six years. Although accumulations of parasites may be partly responsible, it seems that the main factor driving these cycles is behavioural. One study has shown how particularly aggressive males in a population can, by taking and defending bigger territories in autumn, reduce breeding density by up to 50% the following spring, with knock-on effects for the future productivity of that moor.

I once met such a bird in a quiet glen near home. As I edged my car closer, I was grateful that, for once, my subject wasn't camera-shy. I glanced in the rearview mirror only to see, to my dismay, a woman walking up the narrow road behind me. As she passed the car I withdrew my camera and prepared to leave. But the grouse, rather than swearing loudly and whirring off over the moor, began walking up the road to meet her. He pecked furiously at her laces, and she bent down, picked him up and held him in her arms! She was the local keeper's wife, and knew this first year bird well. He died later that year in pursuit of a Landrover.

Ptarmigan

Ptarmigan are tough birds but the increased number of people visiting the hills has not made their lives any easier.

In Britain the ptarmigan is rarely seen lower than about 850 metres above sea level, getting its living on the stony plateau or along its boulder-strewn flanks. For months on end they may need to scrape away snow covering their food, a lean diet of heather, crowberry and bilberry shoots. And in this exposed environment they must blend and move cautiously if they are to avoid the attention of a golden eagle. Ptarmigan therefore have three distinctive plumage phases, according to season. Falling autumn temperatures trigger the winter moult to pure white (excepting outer tail feathers and some around the eye in the male which are black). A partial moult, which leaves the lower part of the breast, belly and legs untouched, leads into the breeding season, then in late summer there is nearly a complete moult and the first white feathers appear on the wings.

Ptarmigan are tough birds but the increased number of people visiting the hills has not made their lives any easier. Concentrations of walkers in some areas leads to increased chick and egg predation by crows (see Dotterel, p. 19). Fences are used extensively in downhill ski areas to accumulate snow on the pistes but research from Norway – and my own observations in Scotland – show that they too contribute to ptarmigan mortality, killing at the very least 1–2 ptarmigan per kilometre per year. When the clouds are down and visibility reduced to a few metres, it's not really surprising that deaths occur when these short-sighted, rather ungainly birds whirr low and fast over the hillslopes. This level of mortality may not appear to be high but when considered alongside the other challenges ptarmigan have to put up with – including the upslope shift of habitat as climatic warming occurs – it is an unwelcome additional burden.

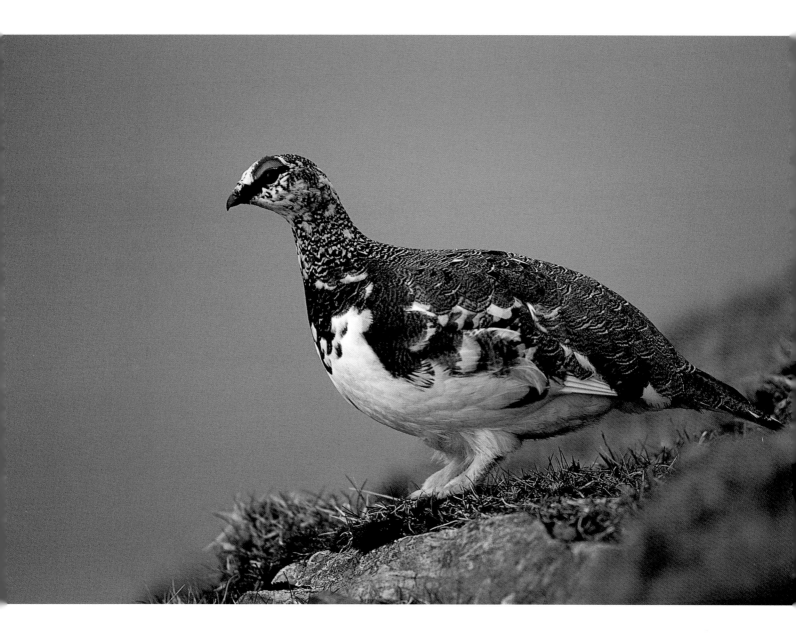

Mountain hare

The hare's grey underfur is especially soft and warm, allowing it to live in winter conditions few other mammals can tolerate.

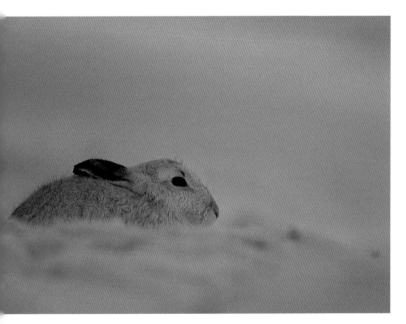

© Neil McIntyre

Long before the brown hare arrived in Britain, probably in the company of Roman settlers, the mountain hare was well established in Scotland. Like the Irish hare (a sub-species), it probably lived on low ground, as it still does in Scandinavia and the Baltic States, though today it is much more associated with the uplands. Like red grouse, the hare favours different ages of heather for feeding and shelter, and is a popular prey item with a range of predators, notably the golden eagle.

Two moults a year – in mid-October to December and again in mid-February to late May – leave little tufts of white or brown fur tangled in the short heather – an ideal nest liner for any vigilant meadow pipit. The hare's grey underfur is especially soft and warm, allowing it to live in winter conditions few other mammals can tolerate. Altitude also determines the timing and completeness of the moult to white. The spring change to brown is hastened by warm days but many animals are caught out, their whiteness against the brown heather a beacon to passing eagles.

Perhaps it was temporary freedom from eagle eyes that made the courting group I watched one April near Inverness so carefree. A shallow bank of dense freezing fog had rolled up the valley as dawn came in, bleaching out the snow-free moor and giving anonymity to anything white. In a strange, silent spectacle, hares emerged from the mist only to disappear again almost instantly, as if in the drift between sleep and wakefulness. Sometimes what I took to be a male edged up towards a female only for the swirling fog to hide the next stage of the encounter. I wandered a little way into the fog, hoping to stalk the animals but found none. Nothing more than tufts of grey fur snagged in the wet brown heather.

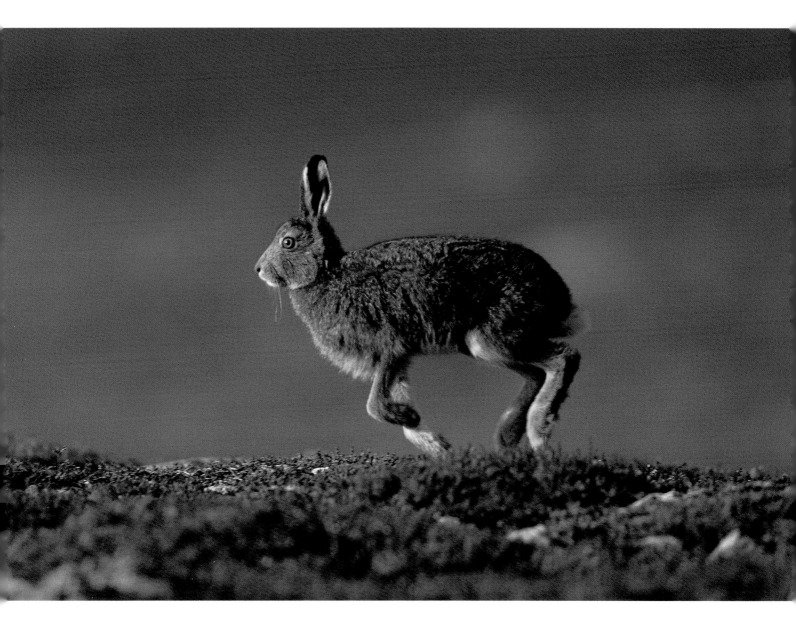

© Neil McIntyre

Snow bunting

A rise in global temperature of just 3 or 4°C could mean that habitats shift upslope by up to 500 metres.

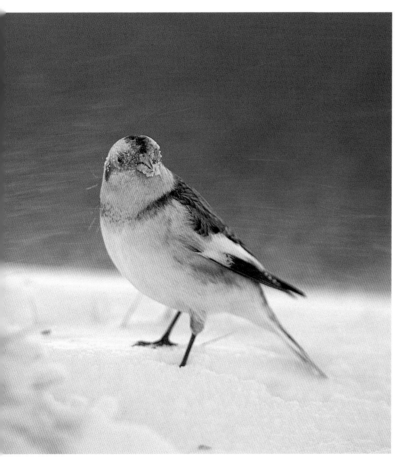

As early as 1988, the World Meteorological Organisation and the UN Environmental Programme set up the Intergovernmental Panel on Climate Change to investigate fears being expressed by a growing number of scientists. These centred on an alarming rise in the level of atmospheric carbon dioxide and the possibility that it might be a factor in the phenomenon of 'global warming'. Few now doubt the validity of the science although specific outcomes remain uncertain. In the mountainous nesting grounds of the snow bunting, however, even small changes are magnified when combined with altitude; a rise in global temperature of just 3 or 4°C could mean that habitats shift upslope by up to 500 metres. And for species like the snow bunting that use the high plateau, there is nowhere else to go.

Fewer than 100 pairs of this chunky bunting nest in Scotland. The male's breeding plumage is a striking combination of black and white, though the hen dresses more in keeping with the buffs and greys of her environment. Each winter most descend to the coast where they are joined by others from the European arctic and sub-arctic. A few, however, choose to stay closer to their summer breeding grounds amongst the high boulder fields and spend the winter around ski-resort car parks scavenging crumbs and gleaning seeds from vegetation exposed by snow clearing work.

Snow buntings can be lured for a close view with grain and this female was one of several feeding just four metres away from my camera. Food for photos seems like a fair deal when times are hard.

Ring ousel

The hesitant, fluty song of the ring ousel has none of the confidence and improvisation of a blackbird's theme.

Characterised as the upland counterpart of the blackbird, the ring ousel is in fact quite a different bird. Superficially the two species are similar, the slimmer ring ousel distinguished by a pale wing patch and the white gorget of both male and female. But that is where similarity ends. The hesitant, fluty song that echoes around empty coires after the ring ousel returns from its Moroccan winter quarters has none of the confidence and improvisation of a blackbird's theme. The bird itself has never developed its lowland cousin's tolerance of people; moorlands and scree slopes, rather than hedges and garden sheds, are its realm.

The ring ousel's wide distribution in the uplands (amongst The National Trust for Scotland properties, it nests on Mar Lodge, Goatfell and the Grey Mare's Tail) should make it relatively immune from the pressures felt by some lowland species, since agricultural practice in these areas is less prone to change than elsewhere. Nevertheless, the bird has been placed on the British Red List of species whose recent population declines give cause for concern. The current population estimate of 6000–7500 breeding pairs compares to the previous level of around 11,000, coinciding with a retreat from traditional areas including the Grampians, Southern Uplands and West Highlands. No firm conclusion has been reached about the cause of the decline – it might even be part of a longer, thus far unrecognized, cycle – but climate change, disturbance by the growing numbers of people using the hills for recreation, and even competition with blackbirds moving upslope are all cited as possible factors.

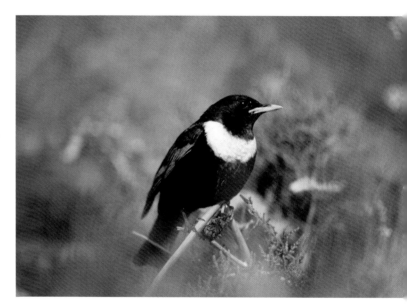

© RSPB Images

Overgrazing by sheep and deer has, especially in the last 50 years, undermined the biological productivity of most of Scotland's uplands and it is possible that the decline of the ring ousel is a symptom of this.

Reindeer

In spite of a long association with people, domesticated reindeer remain all but indistinguishable, behaviourally and genetically, from their wild counterparts.

The issue of 'native' or 'introduced' is a hot topic of debate amongst biologists and natural historians. Any species that found its way to Britain unaided by man, before the post-glacial rise of the North Sea, is generally considered to be native. The reindeer goes one better than this as it was present on the tundra of southern England (which was uncovered during the last glacial period) before the glaciers to the north retreated. The date of its extinction is unclear but it was almost certainly gone by Roman times.

The reindeer that have occupied the northern slopes of the Cairngorms since 1952 could therefore be regarded as reintroductions. And although, as is the case throughout most of their European range, these are domesticated animals, they live year round on the open hillside, ranging over about 2500 hectares. During the rut (September) and calving times (May) the animals are brought into an enclosed area of about 400 hectares, where up to 20,000 visitors a year can meet them. Tilly and Alan Smith are the successors to the founder of the herd, Mikel Utsi, and since 1979 they have built upon his work to make the Glenmore reindeer, now numbering about 140 at two sites, the popular and unusual attraction they are today.

Reindeer are unexpectedly compact animals and this, combined with their apparently easygoing disposition, means that they are sometimes not accorded the respect they deserve. During the 2002 rut, two hill walkers failed to maintain enough distance from a group of females mustered by a bull and were injured by the four-year-old animal. The reindeer had his antlers removed following this rare confrontation.

In spite of a long association with people, domesticated reindeer remain all but indistinguishable, behaviourally and genetically, from their wild counterparts; they might be tame but haven't surrendered their capacity to be wild.

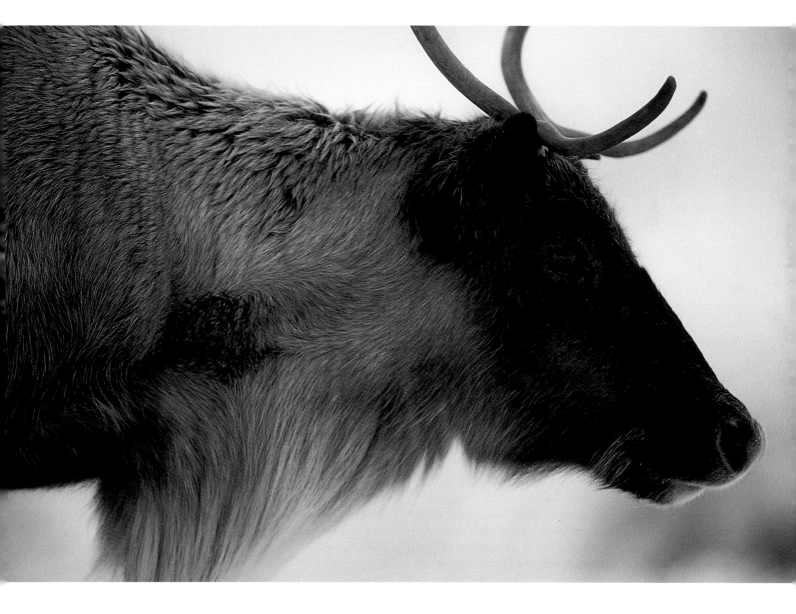

Black grouse

Loss of woodland-edge habitat and upland marshes where chicks feed on invertebrates are significant factors in the black grouse's decline.

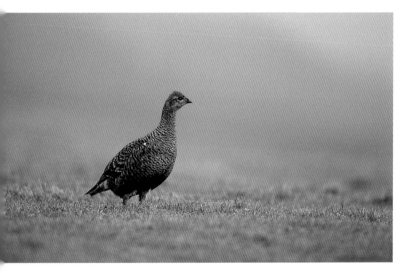

Sitting in a hide as a spectator at a black grouse lek is an experience to savour. Get in well before first light. Enjoy the overture of drumming snipe and melodious blackbird. Feel the frost come in with the dawn and shiver as the birds hurtle in from all directions. Soon there is a steady purring rhythm, randomly interspersed with explosive, two-syllable exhalations as heads are thrown up and wings thrust down. Even without a view of the arena, it's easy to tell when a female has arrived: the performance reaches a crescendo and the fat-necked aggression of the males takes a more serious turn. Birds leap, claws slash, feathers fly. Only as the sun edges over the rim of the blue valley do the birds show any awareness of the hide in their midst.

Opportunities to witness this spectacle are growing ever fewer and bird watchers are now actively discouraged from visiting sensitive sites. The black grouse is currently undergoing a catastrophic decline in many parts of its Eurasian range. In 1990, Britain supported about 25,000 displaying males. By 2001 that number had dropped to about 6500. One bright spot has been The National Trust for Scotland's Mar Lodge property where numbers nearly doubled between 2002 and 2003 alone, totalling 163 displaying males. Loss of woodland-edge habitat and upland marshes where chicks feed on invertebrates is a significant factor in the decline. The Mar Lodge success has been attributed to positive management by The National Trust for Scotland including the removal of 37km of deer fence (with which both capercaillie and black grouse are prone to collide), increasing predator control and forming clearings within plantations which improve the feeding habitat. Bad weather in early summer when the chicks are small is just one of a whole host of inter-related factors that may contribute to the black grouse's fluctuating fortunes, but the fact that local populations can rebuild quickly gives some encouragement to other recovery projects.

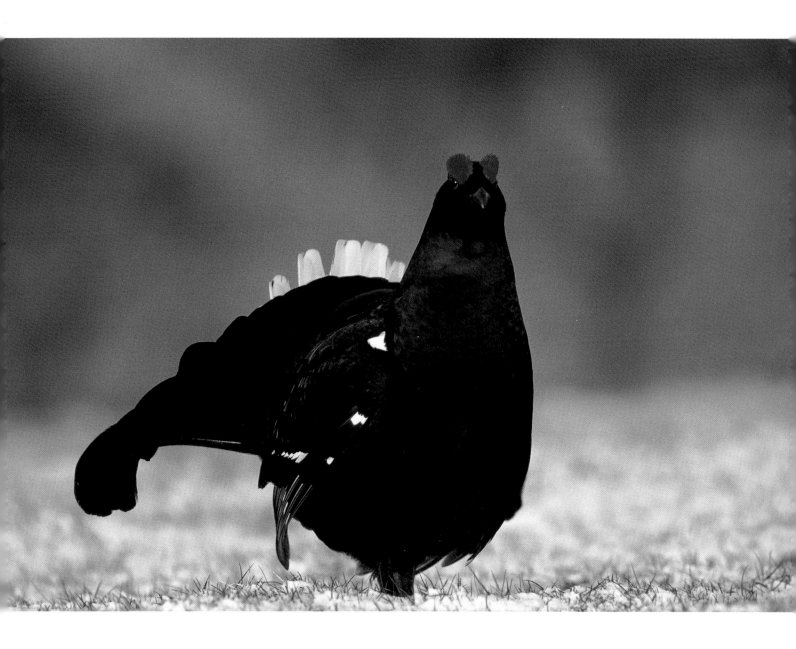

Adder

The sign near Cortachy, Angus, that reads 'Adders Beware' might as well be for their benefit as ours.

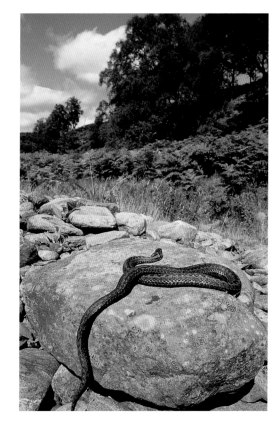

Adders have enjoyed legal protection since 1991 but the legislation is hard to enforce and killing continues. Like slow worms, adders are shy and usually make themselves scarce at the first approach of a person or dog. In springtime, however, when they emerge from communal hibernation, they are not so quick to make their escape. Adders are easier to spot than slow worms since they bask on rocks and gravel paths, especially on moors and in hill districts. As reptiles, they are unable to regulate their body temperature internally, so seek shelter on cool days and shade from hot overhead sunshine. Days with alternating cloud and sun are good for finding them. Experience of the snake in Angus suggests that they have a preference for damper areas for hunting. One small marsh in Glen Esk was for many years an adder stronghold, although each year I found snakes that had been killed. Once I took one home and carelessly left it on the lawn outside my house, only to return half an hour later to find a cat licking its lips and no sign of the adder.

The alternative name of viper refers to the fact that these reptiles are viviparous, that is, they bear live young. Depending upon hibernation and mating times, some females may not eat for more than twelve months, a feat unmatched by any warm-blooded animal.

Adders kill their prey by a venomous bite which initially debilitates the victim – often small mammals, amphibians or young birds. The snake then follows its meal until it drops. Bites to dogs and people are usually delivered only following prolonged provocation. The venomous character of adders is heavily emphasized but in fact many fewer people have died from snake bites (about 15 in Britain during the 20th century) than from reactions to bee and wasp stings. This fact may be small comfort to victims' families but serves to keep in perspective the threat posed by adders to people. The sign near Cortachy, Angus, that reads 'Adders Beware' might as well be for their benefit as ours.

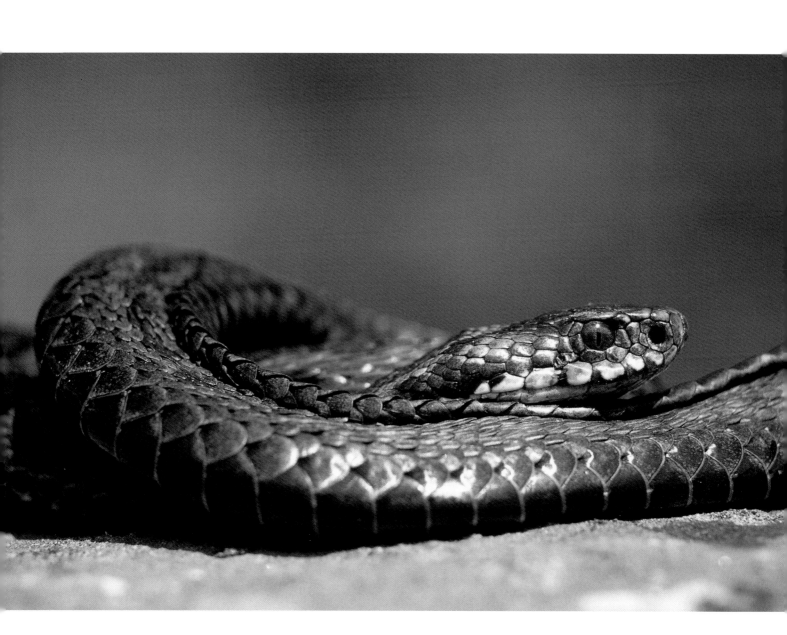

FOREST

Roe deer • Sika deer • Pine marten
Red squirrel • Capercaillie • Crested tit
Scottish crossbill • Woodcock

Roe deer

Unintentional killing by road vehicles accounts for between 30,000 and 50,000 deer deaths in the UK each year.

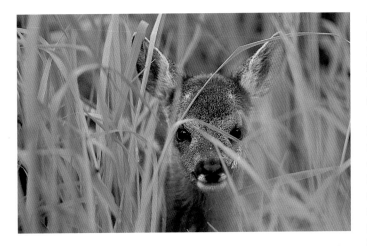

The red deer may have been driven to seek a living on the open hill, but our other native deer, the roe, remains closely associated with woodland. It is quite undemanding in respect of the quality of forest, often using it simply as cover for feeding forays into bordering fields and gardens. The expansion of industrial forests in the 20th century provided refuge for these deer, assisting the growth and dispersal of the population.

The deer's fondness for the nutrient-rich growth tips and buds of plants, however, brings them into conflict with foresters and horticulturists alike. One farmer I knew years ago complained bitterly about the destruction caused by roe deer from the adjacent plantation on his newly planted field of raspberry canes. In a bid to reduce forestry losses the Macaulay Land Use Research Institute has conducted experiments with denatonium benzoate. This extremely bitter-tasting chemical can be absorbed into plant material and remains active for years, deterring browsing by deer and other herbivores. Its use, however, remains limited.

Increased interest in the species amongst British hunters – and those visiting from Europe – in the last thirty years or so has elevated their status from occasional pest to quarry species, bringing with it a closed season. Nevertheless, they are regarded, on balance, as something of a liability by forest managers. For rather more people, perhaps, the roe deer is an elegant if impetuous hazard of a drive in the twilight. Unintentional killing by road vehicles, according to the Mammal Society National Survey of Road Deaths conducted in 2000/01, accounts for between 30,000 and 50,000 deer deaths in the UK each year, with the majority of the victims roe deer.

Males – bucks – are most conspicuous in late summer during the rut when they claim a territory with a bark that seems at odds with their demure appearance. Amongst even-toed hoofed mammals, roe deer are unique in delaying the implantation of the fertilised egg into the uterus until late December/early January. This strategy allows the female both to be in prime physical condition when she is mated and to produce her young (twins where conditions are favourable) in the benevolence of spring.

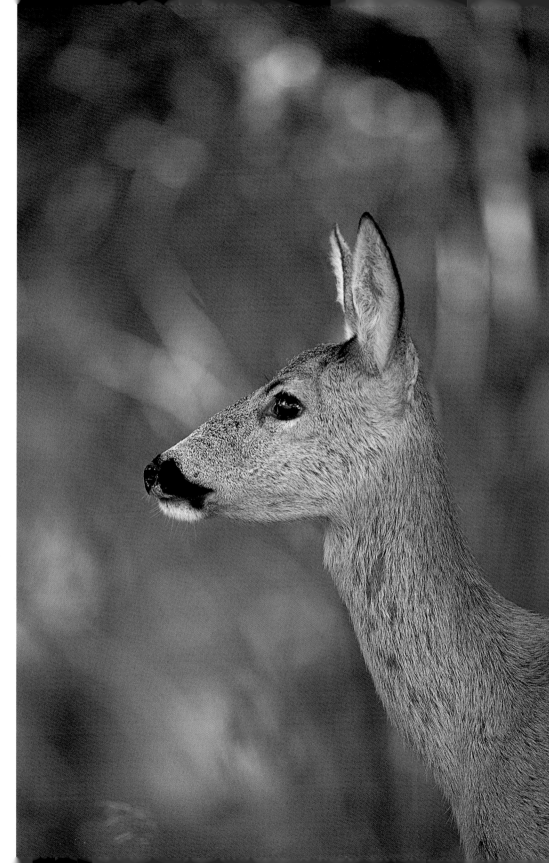

Amongst even-toed hoofed mammals, roe deer are unique in delaying the implantation of the fertilised egg into the uterus.

Sika deer

The sika is easily identified by its distinctive, clean white rump patch which stands out even in the dark forest.

That icon of the Highlands, the red deer, is well and truly on the way to being hybridised out of existence in most of its Scottish range by the Japanese sika deer; some scientists expect genetically pure mainland stock to be extinct in 30 to 50 years. The true culprits, of course, were the Victorian landowners with a taste for the exotic who sought to 'improve' our stock of native wildlife by introducing an animal from the other side of the world, naively expecting the animals to stay in the policies – parkland – where they were first released.

But, inevitably, individuals escaped. They thrived in the new forests that began to rise in Highland glens after the founding of the Forestry Commission in 1919. At home in woodland, they are more fecund than their blood brothers, the red deer, and can live at higher densities – up to 40 deer per square kilometre, depending on the quality of browse available. When disturbed, they retire deeper into these still, sombre forests and become nocturnal. All the while they have found the bigger red deer a willing partner in its own genetic compromise. Indeed, the escaped sikas may themselves sometimes have had red deer blood in their veins. Young sika stags disperse much faster than hinds into areas occupied by red deer and, in the absence of their own species, they mate with young red deer hinds. The progeny are often fertile, suggesting a common genetic history before physical separation helped to define them as separate species.

The sika is easily identified by its distinctive, clean white rump patch, which stands out even in the dark forest. Closer examination reveals the patch to be lined by a black border which may extend down the centre on to the tail – although the black is never as broad as on the fallow deer's tail. It seems likely that more and more people will be able to see these features as the sika's spread is assisted by a new wave of afforestation in the form of community and farm woodlands, leading it into areas once the preserve of red deer. Off-shore island refuges such as Arran, Rum and Jura now offer the best hope for the Landseerian stag. If, indeed, such an animal still exists.

All the while they have found the bigger red deer a willing partner in its own genetic compromise.

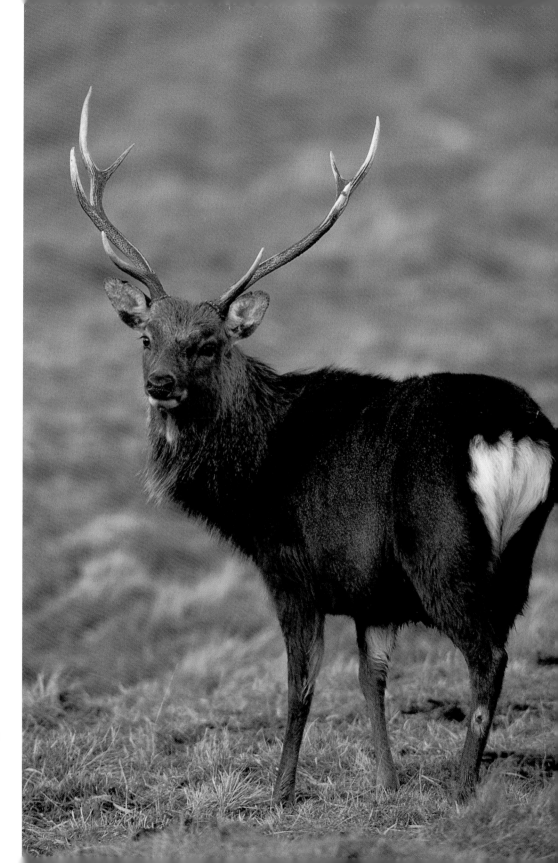

Pine marten

The image of the wild recluse is compromised by the willingness of some martens to take food left out for them (especially jam and raisins) and to raid litter bins.

To listen to wailing martens in a pine wood on a still night is to experience something of primeval Scotland – something rather scary. These animals are persistent survivors, a link to the time when much of Scotland was wild and forests were large enough (and people scarce enough) to support bears and lynx too. These large carnivores were hounded to extinction but the marten clung on. Trapping, at one time for its pelt then as a game-protection measure, made deep inroads into the population, marginalising this overgrown stoat to Scotland's wildest fringes by the middle of the 20th century.

Recent years have seen a resurgence in their numbers, thanks to protected status and the cover provided by industrial forests. This rise has been especially marked in the north and west of Scotland although there have been sightings of martens even in Angus. In a bizarre incident a few years ago, one was found dead in a snare just south of Montrose. Young males are prone to wander, but this one was a long way from known strongholds. Although the heavily urbanised Central Belt is a serious barrier to natural southern expansion, an unofficial release in Glentrool forest in the late 1980s provided the stock for a thriving population in Galloway, now spreading east into the Borders.

The image of the wild recluse is compromised by the willingness of some martens to take food left out for them (especially jam and raisins) and to raid litter bins. Open bins were removed from Glen Affric partly for this reason. Even these animals, though, are rarely seen by day and choose to den in tumbles of mossy scree in the forest rather than under the floorboards of outbuildings as their close relative, the stone marten, does in parts of continental Europe.

The one cloud on the horizon is the escape (or release) into the wild, probably in the 1980s or 1990s, of American martens in northern England. If the two closely related species meet and hybridise successfully, the native marten's genetic purity will be threatened. This is especially problematic in Wales and Cumbria where tiny numbers of pine martens have survived throughout. In Scotland, the Central Belt may prove to be a useful barrier to the northern spread of hybrids.

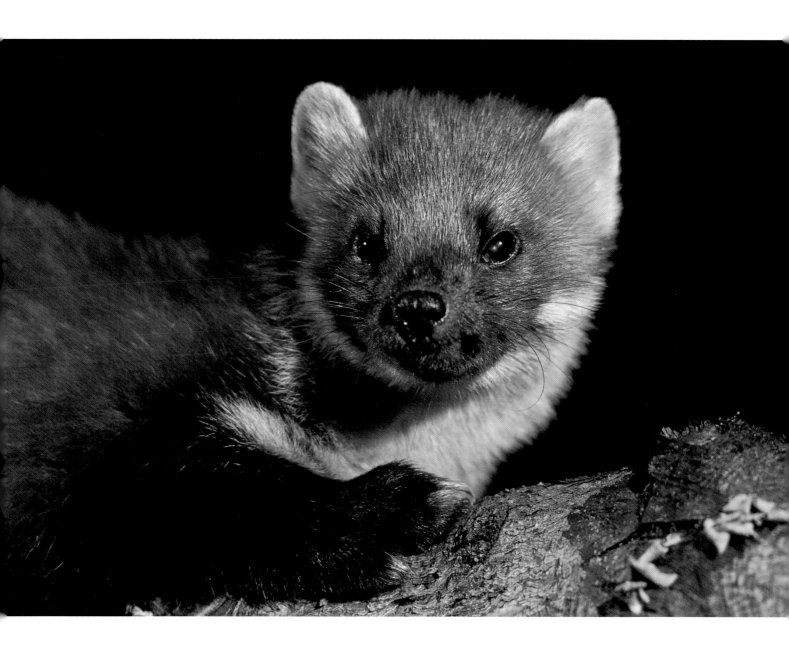

Red squirrel

The species faced extinction in Scotland during the 18th and 19th centuries and was re-established in most of its former range only by the introduction of English and Continental stock.

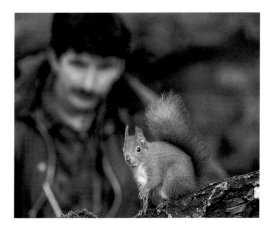

Britain is fortunate to have the red squirrel as a member of its native fauna; it was one of the last to cross the land bridge between mainland Europe and Britain as sea levels rose at the end of the last glaciation, roughly 9000 years ago. During modern times, and probably before, its numbers have fluctuated wildly. The species faced extinction in Scotland during the 18th and 19th centuries and was re-established in most of its former range only by the introduction of English and Continental stock. It is possible that some native red squirrels persisted in the forests of Strathspey. Animals in that area often sport extremely blonde tails – a characteristic found nowhere else – suggesting that they may indeed belong to a relict population.

It was the later introduction of grey squirrels from the US and Canada, starting in 1876 in England and 1892 in Scotland, that has brought the red squirrel to its current precarious state. It is not true that greys oust red squirrels from an area – more often they simply move into suitable habitat vacated by reds for other reasons. Away from pine woods, hazelnuts are a staple foodstuff for both species. But because grey squirrels are able to utilise this food source before the nuts have fully matured, they deprive the more choosy reds of a principal form of nutrition.

In the absence of hazelnuts, red squirrels are forced to turn to acorns which, unlike the grey, they cannot digest satisfactorily. This leads to loss of condition and increased susceptibility to diseases such as parapoxvirus, which is carried, but not contracted, by greys. In fact, it is this disease, rather than direct competition for food, which is at the root of the red squirrel's problems.

Mid-summer is the leanest time of year for red squirrels. Winter supplies have long since been exhausted and the year's autumn harvest of fungi, seeds and nuts is some time away. Supplementary feeding with hazelnuts and peanuts can be a life-saver. Other strategies to help the red squirrel include making forests less attractive to greys by removing hardwood trees, although this can have adverse consequences for other species. Although the embattled red squirrel still prospers in the old pine woods of the north and in plantations of spruce and pine elsewhere in Scotland, many of these woods are fragmented. It is ironic that grant-aided schemes to encourage the planting of broad-leaved trees may make areas currently populated only by reds attractive to greys, further marginalising the reds to relict pine forests and island refuges such as Arran.

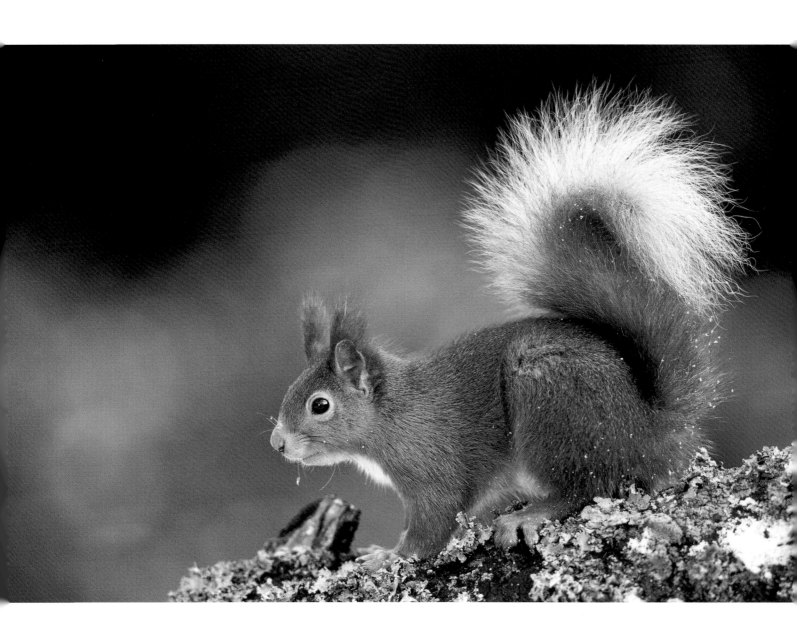

Capercaillie

If, in spite of management and captive breeding programmes, we lose the capercaillie, it won't be the first time.

To witness a capercaillie's dawn display, you need to be in position the night before. It's no use blundering through a pine wood in the early hours of the morning as the birds tend to go to roost in the trees above their territory and, unless you are asleep before them, they will be disturbed. Even more than black grouse, capers can be fantastically pugnacious and fights are picked whenever birds patrolling their respective territories meet. Moreover, every so often there are reports of cock capercaillie that remain active all day long, attacking people, dogs, horses and Landrovers. A bird with a sharp bill the size of a golden eagle's that flies fearlessly at head level is to be taken seriously. Film footage was obtained in Norway of two cocks so engrossed in battle that they failed to notice a golden eagle that swept into the clearing and killed one. The rival re-directed its assault on the eagle, giving up only when the harassed raptor killed it too. All this is supposed to impress the females.

Visits to capercaillie lek sites (display grounds) are now discouraged as the bird has serious enough problems already without additional, avoidable, disturbance. Until November 2001, it was still legal quarry but since then, in response to its alarming decline, it has joined other threatened species on Schedule 1 of the Wildlife and Countryside Act of 1981. A whole host of factors have been blamed for the disastrous decline of this giant grouse. Trials at the RSPB's Abernethy reserve showed that in the absence of fox and crow control, predation on eggs and chicks increased markedly. A significant number of birds have died after flying into deer fences, so in December 2001 the Scottish Executive and SNH made available £770,000 for the complete removal of 87 kilometres of deer fencing as well as the marking of a further 135 kilometres to make it more visible to capers and black grouse.

Capercaillie can live in industrial forest so long as there is a rich understorey where chicks can find food, but they are most at home in old, natural pine woods. In an attempt to improve conditions for the birds, Glen Tanar Estate on Deeside is running a trial programme of prescribed burning under its old pines to stimulate blaeberry, the leaves, shoots and berries of which are summer and autumn staples for the capercaillie.

If, in spite of management and captive breeding programmes, we lose the capercaillie, it won't be the first time; the present population is derived from Swedish stock introduced in 1837 after the first extinction (due to forest clearance) about 1785. A more subtle threat today is posed by acid rain, which makes the damp flushes (marshy areas) in forests less hospitable to the invertebrates that form the staple diet of young chicks.

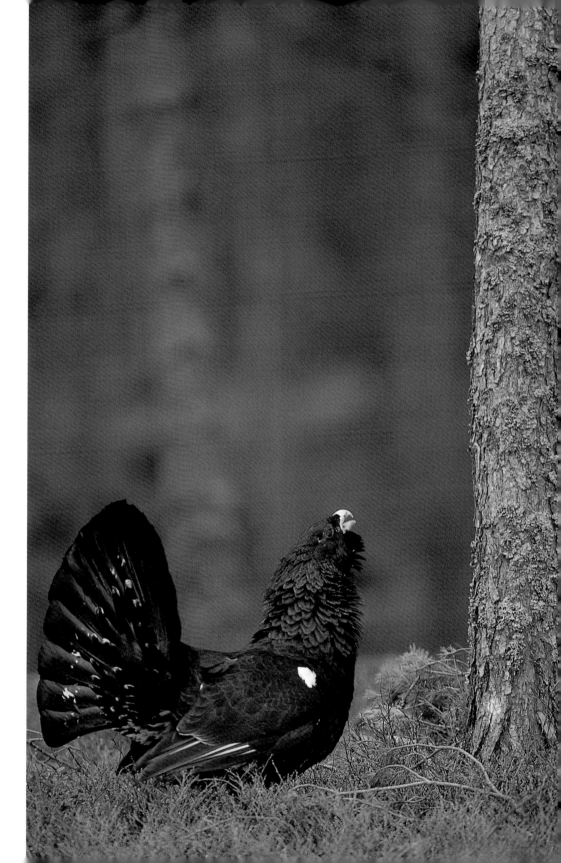

The rival re-directed its assault on the eagle, giving up only when the harassed raptor killed it too.

Crested tit

Crested tits use artificial nest boxes in Norway, the Netherlands and Estonia, and if Scottish birds could learn to do the same their range might be increased.

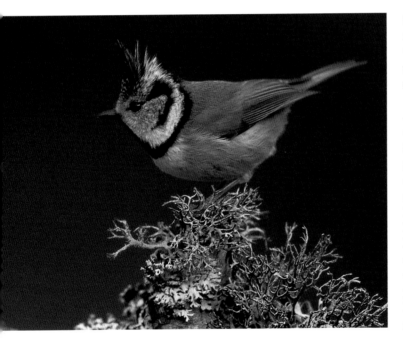

© Neil McIntyre

Like capercaillie and crossbill, the crested tit can get by in mature Scots pine plantations but the old semi-natural pine forests of Speyside and the Great Glen provide much better nesting habitat. The bird needs rotten wood in which to excavate a nest cavity, typically where a branch has broken off an old pine. The way in which plantations are managed results in an acute lack of dead, standing timber, offering little choice of nest sites. Old pine forests, in contrast (especially those managed with conservation objectives in mind) have a much better age mix of trees, including some that can easily be excavated or already offer suitable cavities.

Although the bird is common in coniferous, and to a lesser extent mixed, forests in continental Europe, its status in Scotland, which hosts about 2400 breeding pairs, is more precarious. The highly fragmented character of the remaining old pine forests and scarcity of suitable nest sites in more recently planted areas holds back population expansion. However, hope remains: crested tits use artificial nest boxes in Norway, the Netherlands and Estonia, and if Scottish birds could learn to do the same their range might be increased. A filling of small woodchips, which allows the birds to satisfy their instinct to excavate, has encouraged them to nest even in young plantations and pine scrub. In the past ten years or so, the birds have started to visit garden feeding stations in Speyside on a regular basis, attracting birders and photographers alike.

The RSPB's reserve at Loch Garten is in the heart of crested tit country. Although visitors often hear the tit's distinctive purring trill overhead, seeing the birds as they flit through the pine branches in pursuit of insects calls for a bit more patience. A squeaky toy can be just the thing to lure them in for a closer look.

Scottish crossbill

While we can muster a few races and even sub-species, the Scottish crossbill is our only claim to a fully endemic bird species.

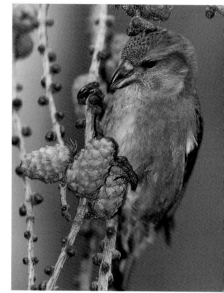

© Neil McIntyre

When it comes to seeking endemic vertebrates, Britain is not the place to look. Its physical isolation from the remainder of Europe is too recent in evolutionary time and the conditions too similar to have promoted the development of novel species. While we can muster a few races and even sub-species, the Scottish crossbill is our only claim to a fully endemic bird species – one that not only is native to Scotland but can be found nowhere else. And with a breeding population of somewhere around 300 pairs, it sits at the top table of Europe's most threatened birds.

But its endemic status is now being questioned by some taxonomists. Recent studies have shown that the Scottish crossbill shares a very similar genetic profile with common and parrot crossbills, from which it is currently distinguished by bill size, calls and feeding habits. It is possible, however, that bill size is nothing more than regional adaptation to forest type. The parrot crossbill has the heaviest set of mandibles, capable of extracting the nutritious seed from Scots pines, whereas the common crossbill has the finest set, more suited to working with spruce and larch cones. Nevertheless, Scottish crossbills tend to mate only with other Scottish crossbills, whose calls they recognize. On this basis, their classification as a distinctive species is legitimate. It is reported from the US and Europe, however, that common crossbills have three distinctive sets of calls and mate only with those 'speaking the same dialect'. Yet they are still regarded as the one species, further muddying the Scottish crossbill's claim to distinctiveness. Crossbills are quite at

home in mature pine and spruce plantations where they nest as early as February to take advantage of the seed harvest. They are not easy to study, however, spending most of their time in the canopy where they keep in touch by a crisp, fluty call. When several birds call simultaneously (they often move around in groups to locate heavily laden trees), the notes seem to collide with each other and reverberate around the forest. A diet primarily of seeds (supplemented in spring by invertebrates and nutrient-rich shoots) means that the birds must descend quite often to drink, and finding a regular watering spot offers the best hope of seeing a crossbill at ground level.

As with several other northern species, including waxwing and nutcracker, the crossbill is subject to periodic population eruptions – in its case following exceptional cone harvests – which see them spread far beyond their normal range. Most of the crossbills found in Abernethy Forest in Speyside are now parrots, following an invasion in the 1990s which displaced the 'native' Scottish crossbills. The three species all occur within the area but remain as separate breeding populations.

Woodcock

Their appetite for worms is voracious; research with captive birds has shown that they can eat their own body weight (about 300 grams) in earthworms each day.

A reedy whistle and a grunt as a dark shape hastens through the gloaming is all that most of us normally see of a woodcock. Males perform these display or 'roding' flights around dawn and dusk throughout the breeding season, usually along the woodland edge, hoping to catch the eye of a female. If he is successful, she will spring above the canopy, then drop down into an open area where he joins her. The rest of their lives, however, are conducted in the obscurity of night, usually in deep cover where

they can feast undisturbed on earthworms and other invertebrates. Even if you were to chance upon an incubating female during the day, the bird's camouflage amongst the leaf litter is so effective that you would most likely walk past by unawares.

The woodcock's reclusive habits make it a difficult species to study but there is a consensus that the breeding population is undergoing a marked decline. This follows a 19th-century expansion attributed to a closed hunting season and planting of dense coverts for pheasants – just the sort of cover favoured by woodcock. The reasons for this decline are uncertain but as forestry plantations mature they provide poorer nesting habitat. Woodcock also love damp forests where they can use their sensitive, almost rubber-like bill to probe the soft ground for earthworms, for which they have a voracious appetite – research with captive birds has shown that they can eat their own body weight (about 300 grams) in earthworms each day. It is therefore likely that very dry summers, such as that of 2003, have a negative impact on the population.

British woodcock are joined each winter by migrants from the Baltic States, Russia and Scandinavia unable to tolerate the freezing conditions that make probing for food impossible. Migration is well underway by late October and this is the best time to see woodcock away from the forest, often in the sand dunes where they make landfall.

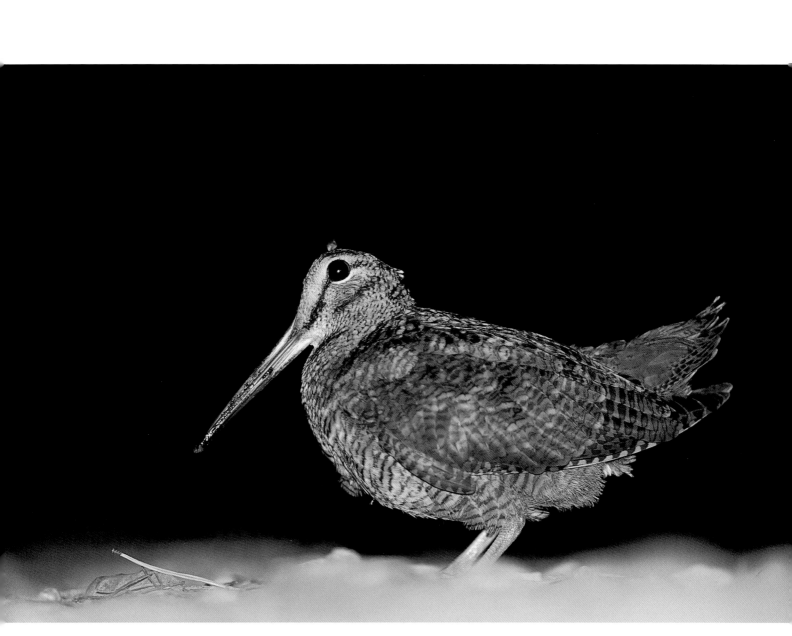

FIELD

Fox • Brown hare • St Kilda mouse • Stoat
Rabbit • Brown and black rats • Common buzzard
Corncrake • Barnacle goose • Hooded crow
Red kite • Pink-footed goose • Twite

Fox

It has been shown time and again that the population of foxes in Britain is directly related to food availability.

Few mammals polarise opinions in Britain as completely as the fox. When did the red squirrel or brown rat ever generate such vitriol between two camps, both of whom profess to have the best interests of the countryside at heart? Of course, the bland defences of 'this is an inhuman way to treat a wild animal' and 'foxes need to be controlled for the sake of other wildlife' conceal fiery passions informed by tradition, pseudo-science, class division, sentiment, envy and just about any other divisive human condition you care to name. Fox hunting simply provides the battleground.

Opinion, even in the conservation community, is divided on how best to manage foxes, if at all. While The National Trust for Scotland and RSPB follow a control policy in the belief that it improves the prospects for rare ground-nesting birds such as the capercaillie, other research suggests that human control makes no significant inroads into fox numbers. It has been shown time and again that, excepting epidemics such as the mange that wiped out most of Bristol's foxes in the late 1990s, the population of foxes in Britain is directly related to food availability. And as we have been remarkably generous to the fox in providing it with everything from discarded takeaways to pen-reared pheasant poults, it is hardly surprising that it is doing so well. In some parts of Europe, rabies, often carried by alien racoon dogs, kills many

foxes, and while enjoying our largely rabies-free status (a small percentage of Scottish bats carry antibodies) we shouldn't forget how that improves the fox's rate of survival.

It is perhaps the lack of vitality of so many prey species that should cause us real concern, rather than the success of one of our few remaining large carnivores. No matter how versatile a (native) predator is, it can only cheat normal predator/prey balances for so long and tinkering with its numbers by hunting is not the way to address the deeper causes of depressed prey numbers.

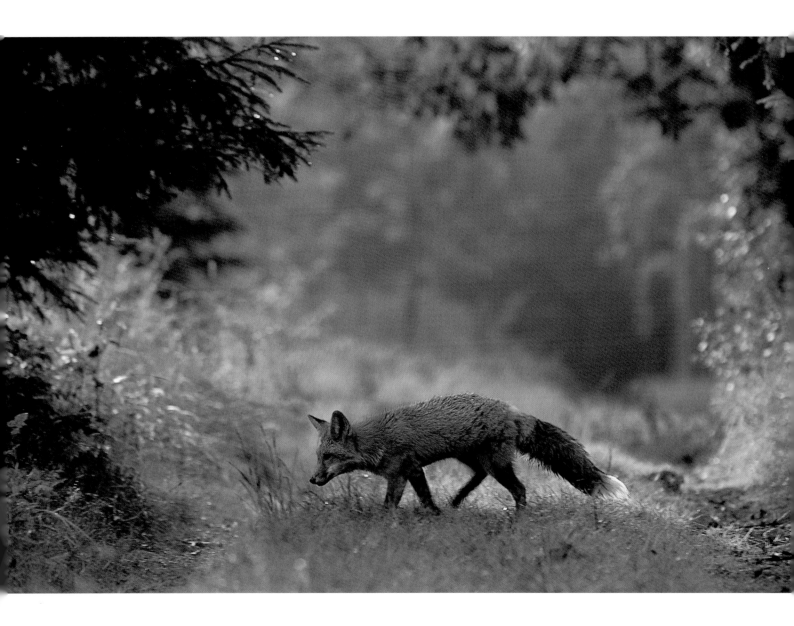

Brown hare

When silage cutting coincides with the time when leverets are very small, mortality is high.

Hares evolved on the Asian steppes and are creatures of open country. Research from the UK, however, shows that they do better in cereal fields bordered by woods, ditches and hedges (providing daytime cover) than in similar-sized grass fields cut for silage. Indeed, when silage cutting coincides with the time when leverets are very small, mortality is high.

It seems that hares failed to cross the land bridge between continental Europe and Britain before sea levels rose at the end of the last Ice Age. They were probably introduced by the Romans to provide sport for their hunting dogs and are now widely distributed, even occurring on some islands. While the hare is generally considered a lowland species, its range sometimes borders that of the native mountain hare in places such as Glen Lyon and Strathdearn.

The hare receives assistance under the UK Biodiversity Action Plan which, amongst other measures, requires that its needs are taken into account when formulating agricultural policy. Hares locally damage young trees though the impact on agricultural crops is generally negligible. In my farming days, I did not welcome them on newly planted strawberry fields. Along with rabbits, they could uproot hundreds of transplants in hours. Nevertheless, there were rather more times when, hoeing weeds alone in the open fields, I welcomed the sight of a hare loping by.

March may be the season of the mad hare, but in fact the animal's breeding season runs in some places from February to October, during which time the jill can produce three litters. Hares are most active at night, for up to 14 hours out of 24; by the time March comes round, their activity begins to overlap with the lengthening days. The boxing matches for which hares are famed are not between jacks trying to impress jills but between the two sexes, typically a female not yet ready to mate and the dominant male in a group. Other skirmishes take place between subordinate males looking for advancement.

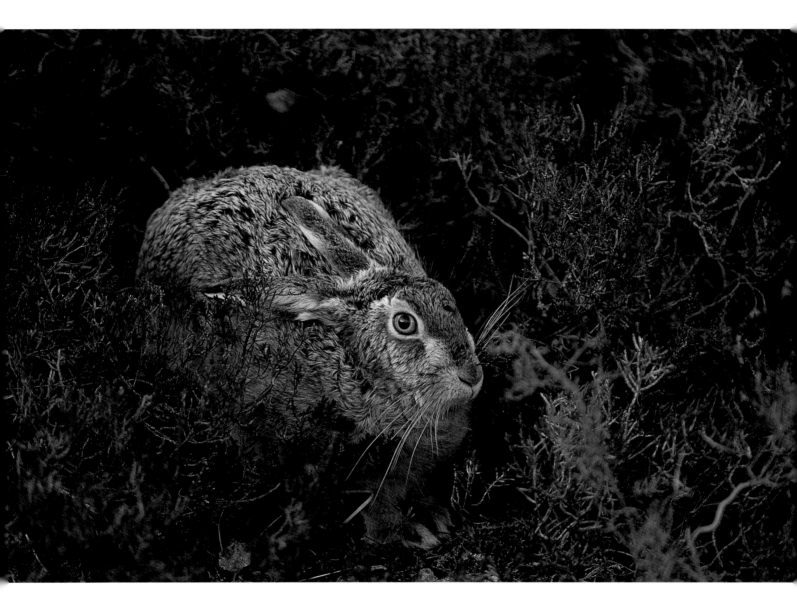

St Kilda mouse

Studies of mouse skeletons indicate Norwegian lineage, suggesting that the pioneer mice may have sailed with Vikings.

The St Kilda mouse, a subspecies of the wood mouse, occurs only on Hirta, the main island in the archipelago, and nowhere else in the world. It is almost twice the size of its mainland equivalent and has proportionately bigger ears and a longer tail. Studies of mouse skeletons indicate Norwegian lineage, suggesting that the pioneer mice may have sailed with Vikings (presumably as stowaways), when they began to use St Kilda as a water stop in the ninth century. Since females are capable of producing several broods a year, evolution into different forms can take place in a relatively short space of time resulting, within about 1000 years, in today's giant.

When St Kilda was evacuated of its final few inhabitants in August 1930, this was the end not only of a 4000-year history of human settlement but also of the St Kilda house mouse, another rodent which owed its presence to the Vikings. It was so heavily dependent on people that, within 18 months of the evacuation, it had died out – as had the domestic cats that relied on it. But the cannier St Kilda wood mouse carried on as before, making its home in the dry stone walls and rocky foreshore of Village Bay and foraging on the land around. Its independence was its salvation.

St Kilda, owned by the National Trust for Scotland, is Scotland's only natural World Heritage Site. The islands are geographically small but they boast Britain's highest sea cliffs, plunging 430m from the summit of Conachair; they support the world's biggest gannetry on Boreray and the Stacs. Stac an Armin, rising to 191m, is Britain's tallest sea stac. It seems appropriate, therefore, that in this realm of superlatives, even the local mouse is a giant. As mice go.

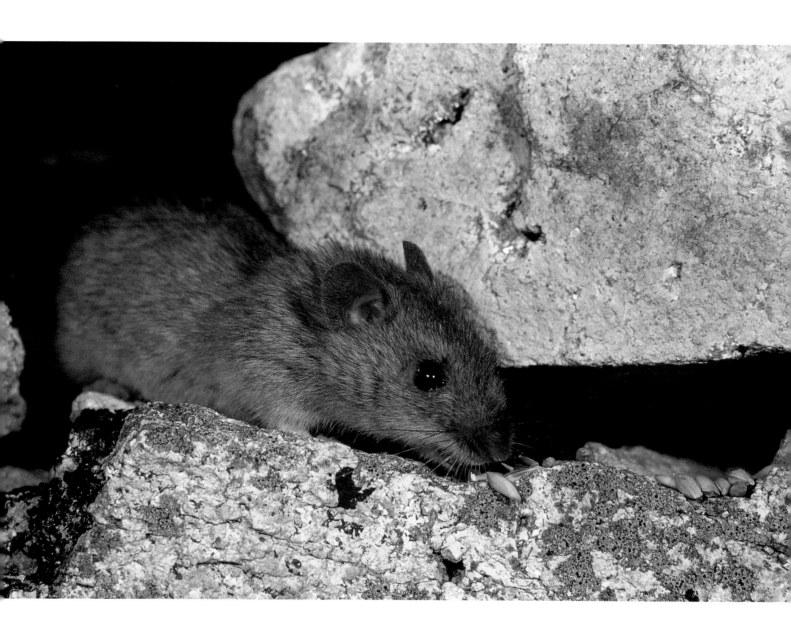

Stoat

The population of stoats is determined by prey abundance, not the other way round, and their fortunes are tied in with those of a number of favoured species.

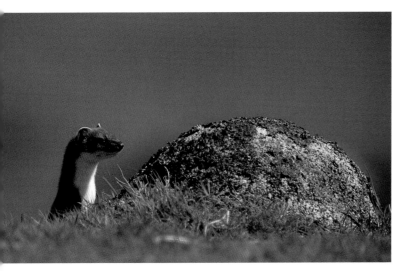

© Neil McIntyre

The various members of the Mustelid family, with the exception of the stockier badger and wolverine, are remarkably similar in build: a slender, lithe body, short legs, a long tail and the teeth and claws of a carnivore. Each species varies just enough from its cousins to avoid serious interspecific competition.

The stoat is the small, multi-purpose Mustelid, living wherever there is food and shelter, hunting mammals up to the size of full-grown rabbits in the cover of field margins and in ditches and walls. As well as hunting, stoats sometimes try to drag away freshly killed rabbits, often becoming road casualties themselves in the process. While the American mink has taken much of the blame for the catastrophic decline in water-vole numbers during the 1990s, the stoat is also a formidable predator where the rodent's numbers are high. The combined hunting effort by two mustelids is too much for the embattled water vole to sustain.

Predation of game birds and more especially 'excess' killing in hen houses and game pens has traditionally provided justification for intense persecution. Yet this is the only sensible strategy for a small predator that needs to eat between 14% and 23% of its body weight each day when the supply of prey is unreliable. We do the same when we visit a supermarket on an empty stomach, buying more than we would if we had eaten beforehand and more than we need because we don't want to repeat the experience of feeling ravenous. In reality, the population of stoats (and the smaller weasel) is determined by prey abundance, not the other way round, and their fortunes are tied in with those of a number of favoured species.

Stoats become especially conspicuous in Scotland during mild winters. Their moult is triggered by day length, but whether the winter coat is white or not is determined by a combination of temperature and heredity. While many English stoats may simply moult into a thicker, lighter brown coat, those in Scotland, especially the north, can turn completely white except for the tip of the tail, which is always black.

Rabbit

The first three months are the most hazardous time for rabbits and only about 10% survive their first year.

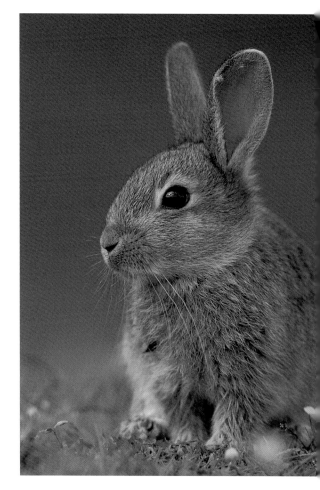

Myxomatosis, introduced from France in 1953, killed about 99% of British rabbits at the time, though enough remained to rebuild the population to the point where it is now at pre-myxomatosis levels in many areas. This is good news for predators from wild cats to foxes, as well as scavengers such as buzzard and red kite. The sharp increase in the buzzard population of the north east of Scotland is due, at least in part, to the abundance of rabbits (see Buzzard, p. 70).

Britain has the Normans to thank (or blame) for bringing the rabbit from the western Mediterranean region in the 12th century. It was an important source of protein and fur although appreciation of wild-rabbit meat has dwindled. Now, a new virus threatens to damage rabbit populations as dramatically as myxomatosis did 40 years ago. Dubbed Rabbit Viral Haemorrhagic Disease, it is thought to have originated in China and, in the late 1990s, outbreaks were reported in southern England. A few cases have appeared in Scotland, including some on Ailsa Craig. It has killed an estimated 60 million rabbits in Italy but it remains to be seen if British conditions will favour widespread development of the disease.

Young rabbits, the first of at least 20 that a breeding doe will produce in a season, begin to appear in April in Scotland. They first venture outside the burrow at about 18 days and at this stage are more curious than suspicious, presenting the best chance of a close approach. The first three months are the most hazardous time for rabbits and only about 10% survive their first year. While rabbits can play an important role in preventing the invasion of grassland by scrub, their grazing and burrowing is often problematic. Rabbit damage costs British agriculture an estimated £100m per year. In addition, archaeologists get upset by their ill-considered excavations of ancient sites and newly planted broadleaved forests have to be protected by netting or tree guards. Fortunately, poisoned baits of the sort used in Australia and New Zealand are illegal in the UK, reducing the number of collateral casualties in the war on rabbits.

Brown and black rats

The two species compete intensely for food to the extent that today only three colonies of black rats remain in Scotland.

While the British may pride themselves as a nation of animal lovers, that 'love' is in fact highly conditional. If you happen to be embattled by alien species, marginalised by industrial development or persecuted by the heartless – and ideally have colourful feathers or a cute furry face – you will enjoy much more sympathy than the plain, resourceful survivor. And if your name has evolved into a term of abuse, no matter how furry your face, forget about being loved.

Such is the fate of the brown and black rats. While the black rat has been in Britain since at least Roman times – and therefore has as much right to claim native status as the brown hare – the brown rat didn't arrive in Scotland until the mid-1730s, most likely in shipping from the Far East. The two species compete intensely for food to the extent that today only three colonies of black rats remain in Scotland – Inchcolm in the Forth, North Rona and on the Shiants, between Skye and Harris, none of which has a population of brown rats. But due to its reputation as a spoiler of stored food, carrier of leptospirosis and bubonic plague and energetic predator of vulnerable birds and other mammals in Britain and abroad, the black rat has few champions.

Perhaps the clearest example of the effect of rat predation on sea birds comes from the studies conducted on Ailsa Craig in the Firth of Clyde by Dr Bernard Zonfrillo of Glasgow University. The first brown rat seen on the island was killed by the lighthouse keeper's dog in 1889, after arriving on a ship delivering coal for the recently built lighthouse. Many more rats followed in the same year and in the early part of the 20th century they were a major problem for the 30 or so residents – as well as the breeding sea birds. A huge puffin colony was wiped out. In 1991, following earlier unsuccessful attempts at eradication, a systematic programme of poisoning took place involving the use of five and a half tonnes of Warfarin set deep into crevices or in bait boxes in more open areas, over a two-year period. The success of the programme has been marked by the improved breeding fortunes of northern fulmars, which have enjoyed a reversal of the total loss of nestlings suffered prior to 1991. Puffins, too, have recolonised. The National Trust for Scotland is now planning a similar campaign on Canna where brown rats are partly responsible for plummeting seabird numbers.

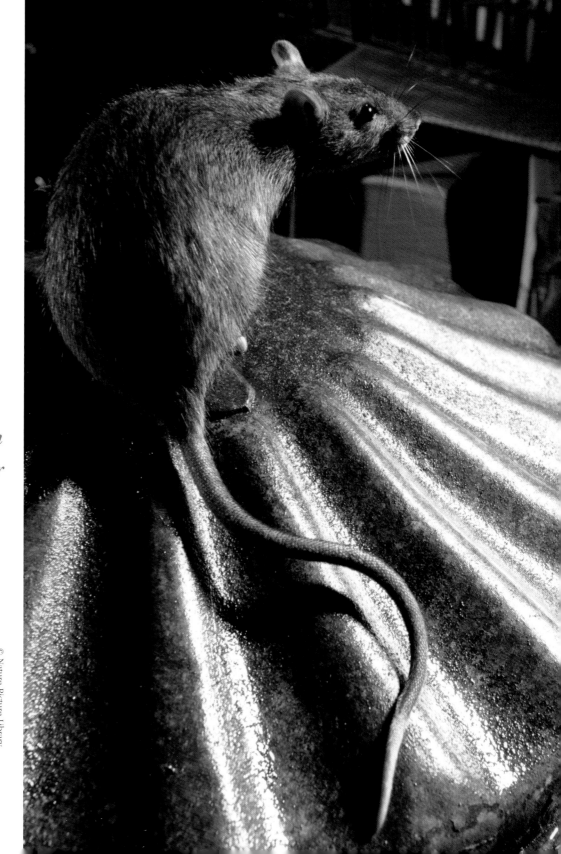

If your name has evolved into a term of abuse, no matter how furry your face, forget about being loved.

Common buzzard

The recovery of the rabbit population to pre-myxomatosis levels (as well as the phasing out of organochlorines) has been a big factor in the buzzard's return.

Of all the recovering raptor species, the buzzard is the most successful and conspicuous, increasing its population by over 220% between 1970 and 1998. In Scotland its numbers grew by 73% between 1994 and 2002 alone. As it has become more numerous, so its range has expanded to cover most of the country, except the high plateau and some islands. In Angus, for example, the bird was formerly seen mainly in the lower reaches of the glens and on forest edges. Now it is common right down to the coast, particularly where mature timber or dense plantations provide nest sites.

During the 19th and early 20th century, buzzards were heavily persecuted by game managers. Two world wars and new rural economics took their toll on the number of gamekeepers and the buzzard population recovered slightly until the population collapse of their main prey item, rabbits, as a result of myxomatosis in the mid-1950s. Since then, they have continued to fall victim to poisoned bait (their scavenging habit, especially in winter, makes them vulnerable to this tactic) and nest and egg destruction. Nevertheless, it seems that the recovery of the rabbit population to pre-myxomatosis levels (as well as the phasing out of organochlorines) has been a big factor in the buzzard's return while maturing forest plantations offer places to nest.

Arguments for control based on the supposed predation of gamebirds are shaky. Examination of prey remains shows that buzzards take a wide range of live prey including, occasionally, partridge and pheasant chicks, but small rodents and rabbits form the bulk of the diet in most places. Their impact on the huge number of tame pheasant poults released in summer and autumn for winter shoots is insignificant when compared to the number that fall prey to cars. But buzzards have been recorded hunting partridges, persistently flushing coveys to exhaust the birds before taking one. As always, though, a buoyant population of predators tends to reflect plentiful prey, in this case rabbits.

In the air, buzzards are sometimes mistaken for eagles – until, that is, an eagle soars into view too. Then the size and shape differences become obvious. The buzzard appears as a well-proportioned bird with rounded wings and a tail that fits it. The golden eagle, in comparison, looks like a pair of massive sails with fingers and a small tail. Habitat can also help in arriving at a correct identification; buzzards are more at home in the glens and wooded parts of the lowlands than the high tops which are the haunt of eagles.

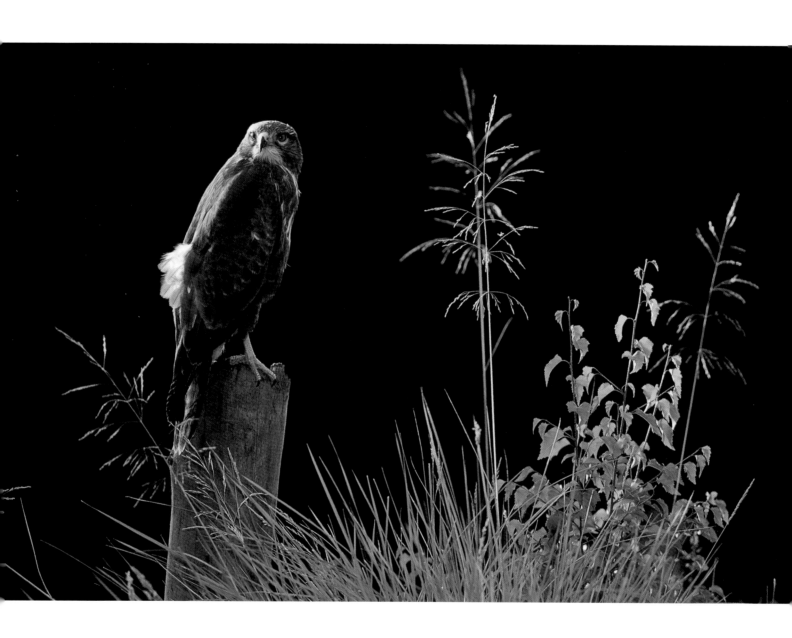

Corncrake

It seems remarkable that such a confirmed agoraphobic can make an annual journey from and to African wintering grounds.

To the Hebridean insomniac, the corncrake is the bird from Hell. Its rasping monotone seems to reach a crescendo during the early hours, coming in irregular, agonising bursts, just as sleep beckons. It is a sound that was once familiar throughout Britain but post-war agricultural intensification and the shift from hay- to silage-making hastened the retreat of the bird to those islands where traditional methods are practised. Scotland currently attracts about 670 pairs of corncrakes each summer with Tiree reverberating to the highest concentration of calling males. In 2003, The National Trust for Scotland had 29 pairs on its properties.

Corncrakes nest amongst long grass, often in the middle of hay fields. The change to silage, which is cut earlier than hay, doomed early broods and even incubating females. Corncrakes are the most skulking of birds, extremely reluctant to leave cover. Since corncrakes may lay eggs well into August (the latest eggs recorded on Coll were still being incubated on 22 August), the bird is vulnerable even in hay crops and the conservationists encourage farmers to employ 'corncrake-friendly' mowing. Rather than starting from the outside of the field and working in (which traps the shy bird), farmers drive into the middle of the crop and cut outwards, giving the corncrake a chance to escape into end rigs.

The corncrake is a remarkable ventriloquist; a bird that sounds as it if it is right beside you may be 50 metres away. You know you are really close when you can hear the 'corncrake growl'. This soft sound is in fact the corncrake pumping up its air sacs, rather like a set of bagpipes, before letting forth its chorus of creks. With its head thrown back, it shouts to the sky a call which, at close range, drills into the listener. They can hide unseen in the smallest patches of sparse vegetation and I have thought sometimes that they can hide behind a single iris leaf.

It seems remarkable that such a confirmed agoraphobic can make an annual journey from and to African wintering grounds. The fact is, however, that many don't make it and the average life expectancy is only about one year. Some compensation for this high mortality rate is made by the bird's remarkable fecundity; female corncrakes can lay between 30 and 40 eggs (in up to three broods) in a single season.

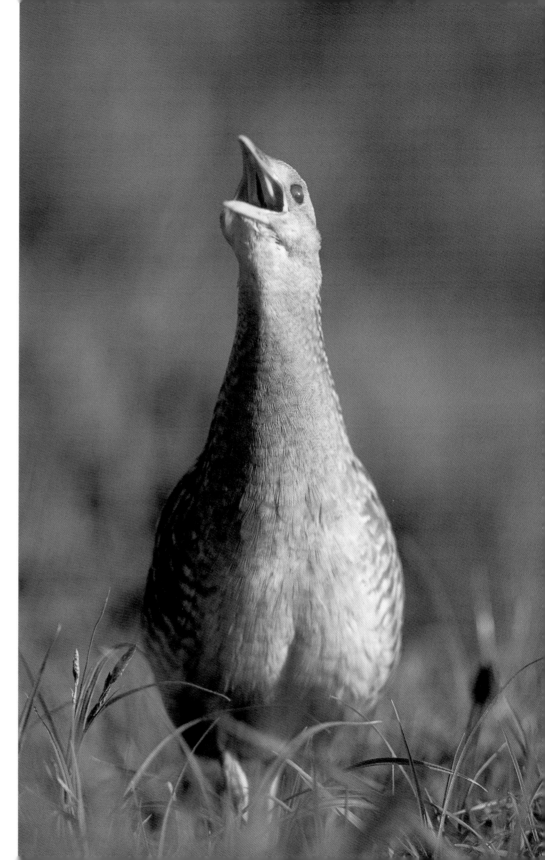

Corncrakes may lay eggs well into August – the latest eggs recorded on Coll were still being incubated on 22 August.

Barnacle goose

When they first arrive, pretty much the entire Greenland population of barnacle geese musters around Loch Gruinart for a few days.

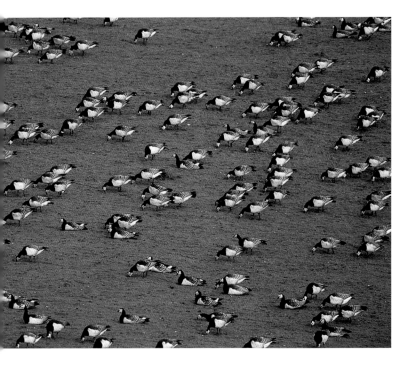

The trouble with a scarce species that likes to congregate in a small area is that it fails to give the impression of its rarity. The barnacle goose, for example, has only three breeding centres; in north-east Greenland, Svalbard and in Novaya Zemlya/Vaigach Island. Each population has a traditional wintering ground: the Svalbard birds come to the Solway Firth, the Russian ones to the Netherlands and those from Greenland head, as their first port of call, to Islay. Indeed, when they first arrive, pretty much the entire Greenland population of barnacle geese – almost 40,000 birds – musters around Loch Gruinart for a few days before dispersing to adjacent islands and the west coast of Ireland.

Islay's rich pastures, until recently grown for the benefit of sheep rather than birds, are a major attraction to the geese and farmers have suffered economic loss on the account of this internationally rare, but locally very common, bird. Scottish Natural Heritage, through the local Goose Management Scheme, now pays out over £500,000 in compensation to livestock farmers annually; it was claimed in the 1999/2000 season that damage cost farmers around £560,000. This figure, however, fails to reflect the boost to winter tourism which the geese bring, something farmers are as free as other islanders to exploit. Participation in this scheme requires farmers to leave geese undisturbed in established refuge zones. The growth in the goose population, from about 8300 birds in 1959 to today's levels, has been assisted not only by the provisions of the Goose Management Scheme and higher-quality forage on wintering grounds but also by measures taken by the RSPB at Loch Gruinart to manage its farm in a goose-friendly fashion. If the population continues to increase, and given the bird's deep loyalty to particular locations, it will be interesting to see if wider dispersal begins to occur and whether there is the political will for compensation payments to match increased goose damage.

Hooded crow

It is perhaps the crow's success in our world that is at the root of the antipathy towards it.

Intelligence, resourcefulness and endurance have not been enough to endear the crow to British people. Perhaps it is its black garb and unsavoury dining habits that typecast the crow as the incorrigible villain. It is condemned, along with its co-accused, the rat and fox, as 'vermin', a word that leaves no room for accommodation. And, as for these other two species, it is perhaps the crow's success in our world that is at the root of the antipathy towards it.

Until 2002, the all-black carrion crow and grey-and-black hooded crow were treated as subspecies of the same species, the hooded occupying the uplands and Highlands, the carrion crow taking the lower ground. But now, based on DNA evidence, the British Ornithologists' Union recognizes them as separate species – a bonus for tick-obsessed twitchers. Coming just months after this split was the news that between 1994 and 2002 the population of hooded crows had declined by 59%, the steepest fall in any Scottish species. This welcome news for game managers is tempered by findings which show the carrion crow's range extending into areas that were previously the domain of the hooded. Numbers may also be related to carrion and gralloch (viscera) availability.

In the absence of suitable nesting trees, hooded crows sometimes take to electricity poles. Where this has happened on Tiree and Orkney, short circuits and power cuts have resulted.

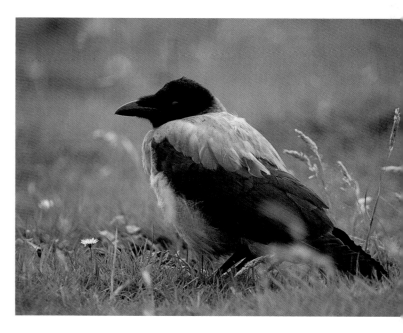

This problem is now resolved by removing the nest then fitting a mirror in its place; the crows are deterred from rebuilding by their own reflection. Crows, as opportunistic predators as well as scavengers, make use of isolated trees as look-out posts and for this reason, grouse moors have traditionally been kept clear of these perches.

Red kite

By 1903, when protective legislation was enacted, only three or four pairs remained, in remote wooded valleys in central Wales. Researchers predict the population eventually levelling out at around 30,000 pairs in the UK.

Egg collecting, illegal poisoning and the marginalisation to poor habitat brought the red kite to the point of extinction in Britain in the early part of the 20th century. By 1903, when protective legislation was enacted, only three or four pairs remained, in remote wooded valleys in central Wales. Although protection allowed numbers to grow slowly, low reproduction rates meant that the prospects for a nationwide re-colonisation were poor, so a re-establishment programme was eventually launched by a number of governmental and charity conservation organizations.

Between 1989 and 1994 a total of 104 birds, mostly of Swedish or Spanish origin, were released at sites in Scotland and England. The second phase resulted in the introduction of 70 kites to the English Midlands, 31 of which were young raised by birds released during the first phase. Central Scotland saw the return of 19 red kites in 1996, their numbers now supplemented by additional birds (until 2000) and breeding success. In the summer of 2003, 35 pairs of kites in Scotland raised 100 young, the first time this figure had been reached for well over a century. The kite's future now seems assured, not least because public attitudes towards it and other birds of prey have improved so much over the last century. In the recolonisation phase, red kites appear to build up their local densities to capacity before spreading out, resulting in a more rapid population growth than in species that disperse while still at low density. On this basis, researchers predict the population eventually levelling out at around 30,000 pairs in the UK.

Sadly this renewed respect is not universal. Carcasses laced with the poison carbofuran, ostensibly targeted at foxes and crows but effective on anything that eats them, continue to kill a range of species. In the spring of 2003 alone, four kites in Scotland were known to have been poisoned and a fifth was found dead with gunshot wounds, apparently having been shot on two separate occasions. The kite is principally a scavenger, supplementing its diet mainly with small rodents and even young crows and pigeons, so it is hard to see any reason behind these killings other than a blind prejudice against birds of prey.

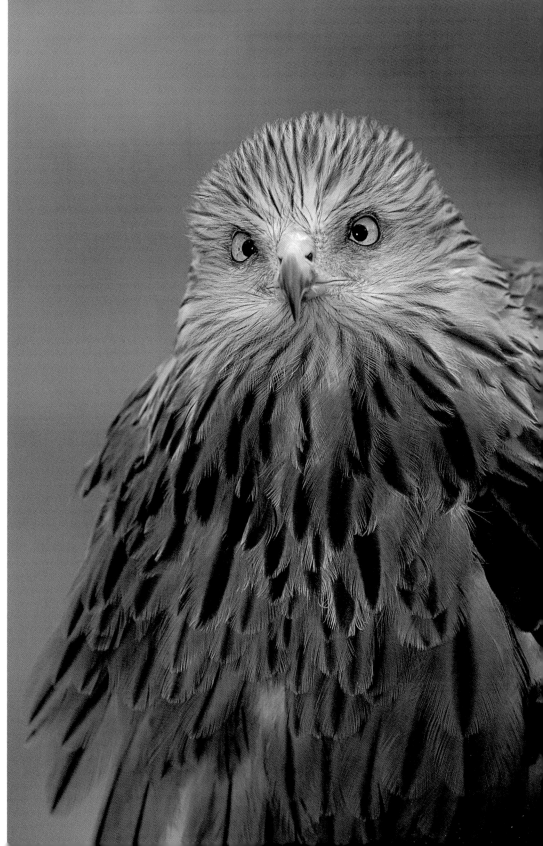

Pink-footed goose

The first pink-foots arrow into our skies in mid September, exciting hunters with a shrill, broken cascade of honking.

The bridge at Montrose railway station not only offers the best view of sunset over Montrose Basin, but also provides a good vantage point from which to watch the pink-footed geese for

which the Basin is an important gathering place. In some years, almost 40,000 pink-foots, out of a total world population of over 225,000, use this tidal lagoon in October as a temporary roost and dispersal site. This species is more wary than its close relative, the greylag, preferring to spend the night on estuaries or large lochs and to feed by day on open farmland. The largest UK concentration of pink-foots is found on lochs in Strathallan and Strathearn where about 20% of the world population passes the winter. The RSPB's Loch of Strathbeg in Aberdeenshire is also a major roost site.

The first pink-foots arrow into our skies in mid-September, exciting hunters with a shrill, broken cascade of honking. At the Basin, smaller skeins come to roost just before sunset, but the majority alight in the centre of the lagoon as night gathers and colours dim. Studies suggest that most will have fed within about 8km of their roost site. Although part of the Basin is a sanctuary, shooting is still permitted over the other half of this Local Nature Reserve – partly on the grounds of tradition. Wildfowling, with its challenge of getting close enough to kill an extremely vigilant wild bird, attracts many hunters to the area. Their activities are tightly regulated and no geese may be sold.

Those reluctant to risk hypothermia in a low tide, pre-dawn vigil on the mudflats can see the birds, albeit without the same sense of intimacy, from the Scottish Wildlife Trust's salubrious Visitors' Centre on the south side of the Basin. Alternatively, the railway bridge offers a good compromise.

Twite

Rather like the corncrake, the twite does better where old crofting practices persist. Unhappily, though, these rarely provide the crofter with a living.

It would be easy to dismiss the twite as just another Little Brown Job, an anonymous, undistinguished upland equivalent of the linnet. In truth, though, it is every bit as emblematic of Hebridean croft lands as the corncrake. Its rapid decline in recent years is causing concern not least because of the bird's relatively small international population and unusual distribution. One population occupies the Atlantic fringe of north-western Europe, concentrated in Norway, the other, the steppes of central Asia, from eastern Turkey through to the Himalayas. In Britain, the bird spends the summer in the uplands, but moves down to the coast in winter to feed on weedy fields and saltmarshes. Scotland holds about 95% of the British breeding population – approximately 64,000 pairs – with 200–500 pairs in the south Pennines.

In comparison to some of our rarest species such as corncrake, chough and sea eagle, the twite seems abundant. But its long-term decline in some areas is worrying. Several reasons have been suggested. Twite typically nest along the edge of moorlands and in field margins on crofts. Where too many sheep graze the moorland edge, the cover provided for a nest by deep heather is removed. As agricultural conditions are improved by drainage and reseeding with rye grass (which overwhelms seed-bearing weeds), so the twite finds it harder to get enough food in these areas. Turnip fields filled with weeds were traditionally a favourite feeding ground, but effective selective herbicides have reduced this food source too. Rather like the corncrake, the twite does better where old crofting practices persist. Unhappily, though, these rarely provide the crofter with a living.

In addition to trying to maintain or improve breeding and feeding habitats, other measures to help the twite may include the provision of corn (oats) on reserves where they presently winter, the exclusion of sheep from the moorland edge in important breeding areas and the discouragement of tree planting (particularly conifers) in prime breeding habitat. In helping this more humble member of the Hebridean community, others will benefit too.

WETLANDS & RIVER

European beaver • American mink • Common frog
Atlantic salmon • Curlew • Water vole • Dipper
Red- and black-throated diver • Redshank • Goldeneye
Grey heron • Lapwing • Osprey
Common and wood sandpiper • Whooper swan

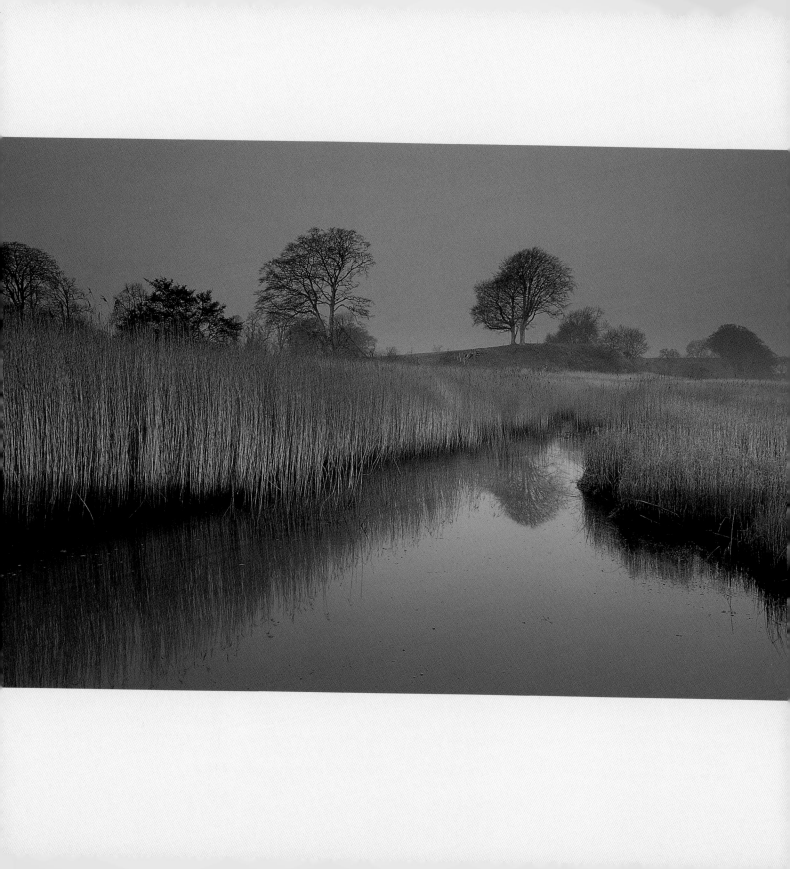

European beaver

Beavers have little taste for commercially important trees such as spruce and pine, preferring instead aspen, willow, alder and birch.

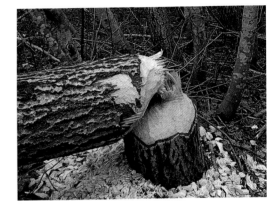

The inclusion of this species in a book on Scottish wildlife is, at the time of writing, more the expression of a hope than a reflection of the current situation. Amongst the countries which have failed to restore the beaver to its former haunts, Scotland stands alone with Portugal, Italy, Greece and parts of the southern Balkans – none of which are noted for a strong conservation ethos. That the beaver is not yet revitalising Scottish wetlands can be seen primarily as a political rather than a practical problem – in spite of widespread public support for the return of the beaver after a 400-year absence.

The beaver is a landscape manager par excellence. If necessary, it manipulates water levels by damming to ensure that access to lodges or burrows remains inundated at all times – or simply to improve access to food. Dams act as filters, oxidising pollution, deacidifying and improving water quality within a catchment. In Latvia, with its population of 100,000 beavers, about 32 billion cubic meters of water are purified in this way annually – something that would cost about £40 million to do artificially. This has positive benefits for fish stocks and far from harming prospects for salmon can actually improve conditions for them. Dams are small compared to those of Canadian beavers – usually less than one metre in height, presenting no serious obstacle to migration; the two species co-existed for millennia, after all, before our ancestors hunted the beavers to extinction. Beavers have little taste for commercially important trees such as spruce and pine, preferring instead aspen, willow, alder and birch.

It seems, however, that an influential lobby deeply opposed to any challenge to its primacy as land managers has been able to stall Scottish Natural Heritage's plans for a tightly controlled, closely monitored trial release in south-west Scotland, despite majority support locally and nationally. So far, the government agency has been refused a licence to import animals from Norway by the Scottish Executive. The European beaver is one of the most intensively studied mammals in Europe with an enormous literature pertaining to reintroduction effects and the Executive's stated reason for delay – that more research needs to be done before the trial can begin – is unconvincing. In the meantime, Scotland loses out from the absence of an animal that improves conditions for other wetland species at no cost, presents minimal problems to foresters and no threat to fisheries and would act as a valuable tourist attraction. If getting the beaver back to Scotland is so difficult, the omens are not good for the restoration of any of our other missing mammals and birds.

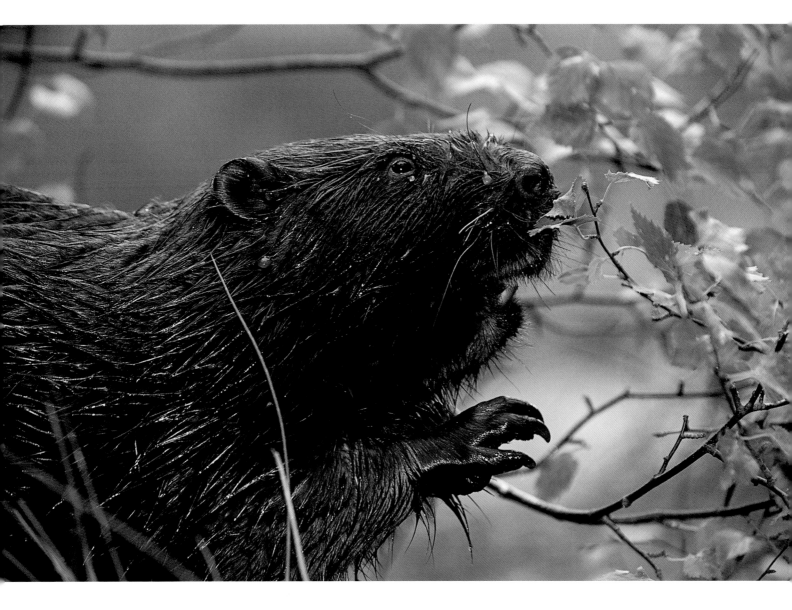

American mink

New research suggests that the American mink may not have a free run for much longer.

Ever since American mink began to escape from fur farms in the UK in the 1970s, river managers and other conservationists have worried about their impact on native wildlife. Water voles have been particularly hard hit, although their decline had started even before feral mink populations were widespread. The mink has found conditions favourable here and, for a long time, lack of competition allowed them to prosper. In 1999, 70 years after they were first farmed in Britain for their warm pelts, feral mink appeared on the Outer Hebridean islands of North Uist and Benbecula.

This is of particular concern because of the internationally important populations of wading birds that nest on the

Hebridean machair – those narrow coastal plains behind west-facing beaches that are enriched by wind-blown shell sand. The mink is primarily an aquatic predator but, given an abundant, albeit seasonal, terrestrial food source, it is equally at home on land. A live trapping programme began in 2002 and by May 2003, 232 mink had been caught (along with 129 ferrets and 1352 rats – other predators of these birds) by the 12 trappers employed by the Hebridean Mink Project.

In continental Europe, the American mink is one of the main culprits in the demise of the native European mink, a species on the verge of extinction in the wild. Not only do the two species compete for food but the more aggressive male American mink mate with the female Europeans as soon as they come into oestrus, causing her to repel suitors of her own species, but not resulting in viable young. The European mink is now subject to an intensive captive breeding programme, and it is hoped to re-establish a free-ranging population on the Estonian island of Hiiumaa – itself free of Americans.

New research suggests that the American mink may not have a free run for much longer. Not long after the introduction of organochlorine pesticides in the 1950s, otter numbers plummeted and the niche they vacated was soon filled by the mink. But now that otters are making a comeback in many areas, there is firm evidence that they have a depressive effect on mink numbers. This, however, provides little relief for the birds of the machair where the coastal otter population has remained buoyant, clearly providing little deterrent to the colonising mink.

Common frog

Frogs provide a useful mineral supplement for red deer in bogs where calcium is in very short supply.

It is a measure of Scotland's geographic isolation – and challenging climate for the cold-blooded – that it can claim only one native species of frog. That is natural. What is more troubling is how uncommon common frogs have become over many parts of the country – troubling not only for their own sake but for the higher vertebrates that feed on them. Latvia, in comparison, has one of the highest densities of amphibians, including the common frog, in Europe. Numerous small ponds and lakes and minimal use of agro-chemical provides a much higher-quality habitat than is found in much of lowland Scotland where most farm wetlands have been drained and contamination of watercourses with chemical run-off is common. Their abundance is reflected in the Latvian otter's diet; in winter, frogs account for more than half the biomass of prey. But in my home county of Angus, famed for its agriculturally productive lands, it is now much more common to come across springtime masses of frog spawn in the glens, where quite often it is killed by late frosts, than it is in the lowlands. Frogs may not feature so highly on the otter's menu in Scotland but they do provide a useful mineral supplement for red deer in bogs where calcium is in very short supply.

Frogs do not occur naturally throughout Scotland and their presence on some islands is the direct result of introduction. It is over ten years since they were brought to Lewis in the Outer Hebrides where they have thrived in lochs in Great Bernera, Marybank and Acha Mor. There are now concerns that their predation on the spawn of wild brown trout is suppressing local populations. It is to be hoped that the local otters will, in turn, learn to exploit this new resource, as their Latvian counterparts do.

Atlantic salmon

It is estimated that in the open ocean there are now as many farmed as wild salmon.

With fishing on some of Scotland's best salmon beats costing in excess of £1000 per day, it's not hard to imagine the importance of the wild fish to the rural economy. The Dee valley alone benefits to the tune of £6m a year. But while some rivers, such as the Tweed, are currently producing good numbers of fish (10,300 landed by rod in the 2002/03 season – the best in a decade), there was an overall decline of 45% in the population of wild salmon between 1983 and 2001. Salmon became extinct in a number of rivers in Lochaber and Wester Ross, areas with a high concentration of aquaculture. Production of farmed salmon grew 55-fold over 20 years to reach 700,000 tonnes in 2002. Most large fish farms are now owned by multinationals and employ relatively few people so the local economic benefit is not as significant as it might be.

For a long time, drift and stake netting was blamed for taking too many salmon out of the river mouths. Now that most netting stations have now been bought and closed by salmon conservationists led by the Atlantic Salmon Trust, the blame has shifted squarely, if not entirely fairly, onto fish farming as the primary cause of the salmon's problems. Sea lice thrive in the densely packed pens where salmon are reared. When farms are placed near the mouth of rivers, wild salmon smolts taking to the sea for the first time become infested. Huge numbers of farmed fish escape annually – 16,000 in just one incident in 2003 from a fish farm in Loch Ewe – leading to concerns about the genetic integrity of the wild population. One Irish study published in 2003 found that when wild and farmed salmon hybridised, nearly three-quarters of third-generation salmon embryos died within their first three weeks, so ill-adapted were they to life in the wild. It is estimated that in the open ocean there are now as many farmed as wild salmon. In focusing on the adverse effects of aquaculture, it is a mistake to overlook the impact made on wild salmon populations by the high seas fishery off Greenland, something that may have a more direct bearing on fish returning to east-coast rivers.

But the news is not all bad. Many rivers along the west coast, between the Clyde and Wester Ross, have seen a recent increase in salmon numbers. In 2002, the Rotten Calder, which feeds into the Clyde at Rutherglen, hosted its first juvenile salmon in a century. Elsewhere, improving water quality, removal of impediments to movement, such as weirs, and more effective treatment of sea lice in fish farms are contributing to the recovery. But a longer-term threat remains in the shape of climate change. The salmon is a cold-water fish and if the river temperatures experienced in the summer of 2003 – the Dee rose to 21°C in August – were to become the norm, the salmon might disappear altogether.

Curlew

Curlews are big waders with lots of attitude and if they don't like having you in their territory they let you know.

For many people, the curlew's bubbling trill evokes memories of the high moors in summer more keenly than any other sound. It is the sound of open space and big skies. While post-war drainage of wet pastures – the favoured breeding habitat – has checked population growth, this has been offset to some extent by birds adapting to cultivated low ground.

Curlews are big waders with lots of attitude and if they don't like having you in their territory (especially when they have chicks) they let you know. But my experience of the curlew in winter, when they flock to ice-free shores and mudflats to probe for ragworms and other littoral invertebrates, is of quite a different bird. Three hours before high tide at Montrose Basin, near The National Trust for Scotland property of the House of Dun, I take an amphibious hide on to the mudflats, about 150 metres from where the birds congregate at high tide. As the Basin begins to flood, I gradually drift towards the roost site, arriving at the same time as the high tide. Curlews preen and feed five or six metres distant. Within the bird's own space, this is the time to see it relaxed, defending its patch of shingle from industrious turnstones or lugubrious eider ducks. It is unlikely, however, that these are the same curlews that breed in the

nearby Angus glens; after the breeding season the population as a whole tends to move south west so that local birds winter in western Britain and Ireland while Norwegian ones come to the estuaries of the north east.

With over 20% of the European population of curlews nesting in the UK, care needs to be taken to ensure that enough habitat is retained so that its call can continue to define the spirit of the uplands.

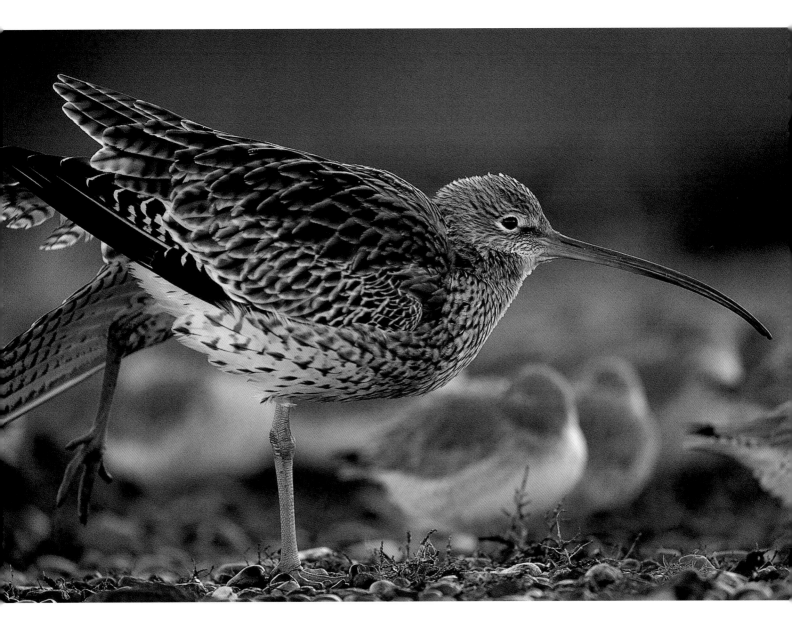

Water vole

Populations have recently been discovered on The National Trust for Scotland's property at Ben Lawers and in the Cairngorms at 820m.

The revelation that we have several captive breeding programmes for water voles in Britain in a bid to restore them to former sites is always met with some incredulity by friends in central and Baltic Europe. In Latvia and Estonia, for example, 'Ratty' is regarded as nothing more than a pest and the fact that the British would spend money breeding voles for release is evidence of our incorrigible sentimentality.

But the population of water voles declined by 90% in Britain during the 1990s. Conservation measures are therefore based on need rather than sentiment. Strongholds do remain in the north and west of Scotland and populations have recently been discovered on The National Trust for Scotland's property at Ben Lawers and in the Cairngorms at 820m. Elsewhere in the country, however, the characteristic 'plop' as a vole enters a slow-flowing stream is no longer heard. The drainage of wetlands and pollution with agrochemical run-off set the stage as early as the 1950s for today's state of affairs. The quality of our lowland wetlands is generally poor compared to, for example, Latvia, where minimal chemical use (for economic rather than ecological reasons) encourages species-rich ponds and streams and provides the conditions for one of the most abundant populations of amphibians in Europe.

The decisive blow to the water vole has been dealt by American mink, a non-native, semi-aquatic predator whose catastrophic impact on a whole range of riparian species is now well understood (see p. 84). In habitat that has already been degraded, water voles simply cannot sustain the level of predation by mink, whose wide tastes allow it to exploit a wide range of prey. Conservation efforts are now being concentrated on dense reedbeds, where the water vole has been shown to be relatively safe from mink.

In vole territory, the animals are relatively easy to find. They are large – adults are the size of brown rats, though without the tail. They leave narrow pathways through dense vegetation as they make their way to the water's edge. Here they often feed in the open on the platforms of floating vegetation that accumulate at these entry points. Although most feeding happens at ground level, I've seen a water vole climb a great willowherb plant to reach some succulent leaves, the plant bowing sharply under the weight of the eager rodent.

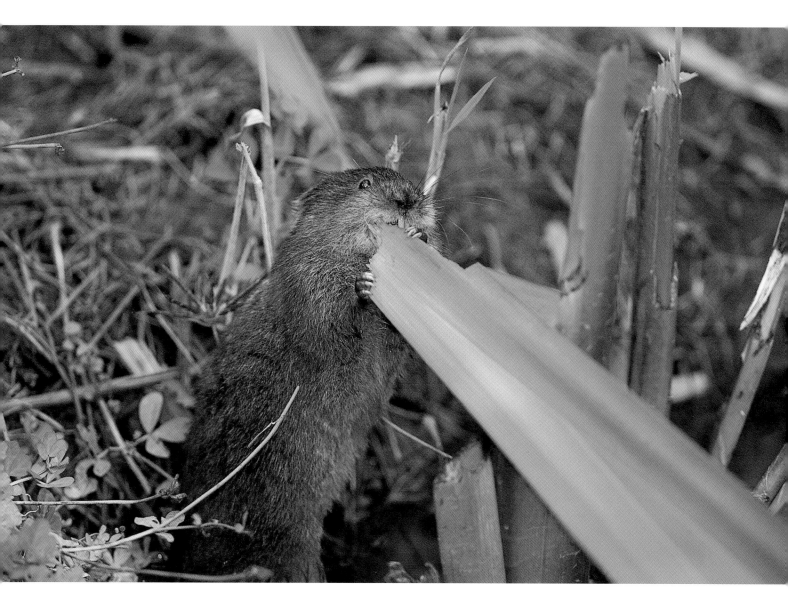

Dipper

Given clean water, the dipper seems set to benefit from global warming as its winter feeding grounds remain ice-free for longer.

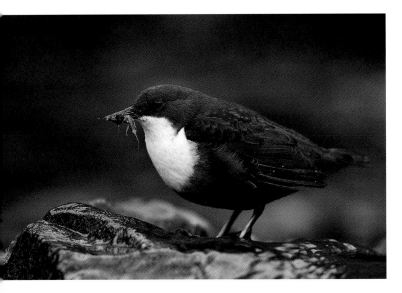

The dipper is unique amongst British birds in the way it finds food. By 'flying' underwater, against the current, it can walk along the beds of shallow, fast-flowing streams, delving amongst stones for caddisfly larvae and other insects. Its heavy reliance on these aquatic invertebrates makes it a good indicator of the health of a water course – regarding not only the presence of pollutants but also the degree of acidification. Given clean water, the dipper seems set to benefit from global warming as its

winter feeding grounds remain ice-free for longer. It is also laying clutches on average seven days earlier than 30 years ago, probably in response to climate change. But dippers can tolerate very cold winter temperatures, even if getting access to flowing water involves diving under ice. There are dippers resident in northern Norway where winter temperatures drop to –35°C and total darkness descends for two months each winter. As soon as access becomes impossible, however, the dipper must go to the lower reaches of rivers where increased flow and mixing with sea water keeps them ice-free. Dramatic rises in water level cause them more difficulties, especially in spring when excessive turbulence makes it hard to feed. Dippers naturally nest in river banks, where they build an intricately woven ball of moss and grass lined with leaves and hair, so are vulnerable to spring floods that undercut them.

Many dippers choose to nest on man-made structures by the river, most commonly bridges. The H-shaped girders often used to make small bridges provide an ideal shelf but many potential nest sites are lost when the undersides of old bridges are reinforced with concrete. In these locations, dippers readily take to nest boxes which should automatically be provided when strengthening work takes place. This is especially important as successive generations of dippers are extremely loyal to nest sites, suggesting a shortage of choice. One site in Dumfriesshire was even reputed to have been in use for 123 years.

Redshank

Redshanks are more solitary feeders than some other waders, reflecting their choice of food on the mudflats.

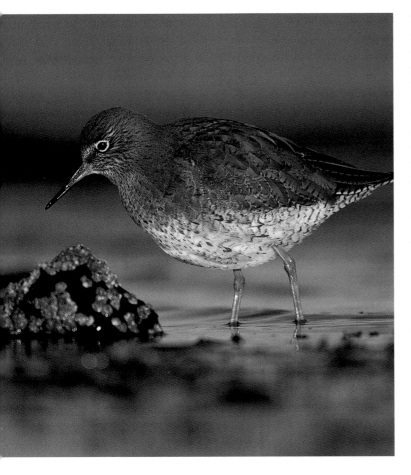

With its bright orange legs, three-syllable call, and V-shaped white rump and wing bars, the redshank is one of the more distinctive waders probing the mud of Scottish estuaries in winter. More northern populations, including up to 60% of the Icelandic one, migrate to Britain in winter to take advantage of ice-free feeding conditions. Redshanks are more solitary feeders than some other waders, reflecting their choice of food on the mudflats. Much of it occurs on or close to the surface – the crustacean *Corophium volutator* is a major prey item – and a gathering of birds would be more likely to frighten it away. In Scotland, most feeding in winter happens during the day but if high tide makes the mudflats inaccessible during these hours, they take to neighbouring fields to feed on earthworms and cranefly larvae, by day and night.

These items form a large part of the diet of birds on their breeding grounds in damp fields and salt marshes. Some of the highest concentrations are found on the Hebridean machair although there, along with other ground-nesting waders, they have suffered intense predation from alien hedgehogs and American mink. Lapwings are especially sensitive to the approach of potential predators and redshanks take advantage of this early warning by nesting close to them. It has been shown that nesting within 50m of a pair of lapwing reduces the likelihood of nest predation by about half. While in rough, wet grassland no more than three pairs of redshank normally nest per hectare, that number can climb to ten or more on saltmarshes and machair. At these higher densities, redshanks become effective watchdogs for each other.

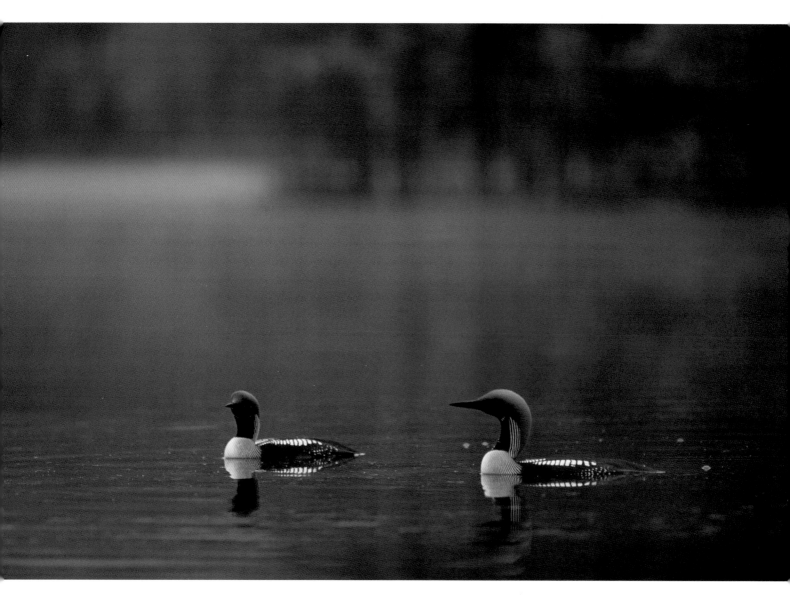

Red- and black-throated diver

The breeding success of black-throated divers has improved markedly on some lochs, such as Loch Maree, with the provision of artificial nesting rafts.

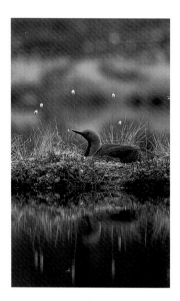

© Neil McIntyre

The delicate balance between the needs of wild animals and our need to generate energy from renewable resources is highlighted in the case of the black-throated divers living near Shieldaig in Wester Ross. Here, following a failed application in the late 1990s, a power company is again seeking approval for the construction of a 2.1 MW hydro-electric power station. Objections have been raised not only on the grounds of its scenic impact but also because it threatens an internationally important colony of freshwater mussels in the River Kerry and three of Britain's 155 nesting pairs of this diver. Similarly, concerns about a proposal to develop a massive, 300-turbine windfarm on the Isle of Lewis in a Special Protection Area of blanket bog could be put in jeopardy by, in British terms, significant numbers of red- and black-throated divers nesting in the area.

It has been estimated that Scottish peatlands reduce the atmospheric carbon dioxide load by up to 250kg per hectare per year and that opening them up releases 10 tonnes of CO_2 per hectare for five years as partly decomposed vegetation is exposed to the air. Such exposure is inevitable when constructing the windmills, but that has to be offset against the reduction by 1.8 million tonnes of CO_2 emissions per year (compared to fossil-fuel energy generation) that the Lewis development would bring. The decision as to whether birds or turbines take precedence may ultimately be one that comes from the European Commission.

Divers are prone to disturbance by people but they are also highly vulnerable to rising water levels when they have eggs. About 30% of black-throated diver clutches fail for this reason. Both species tend to nest very close to the edge of the water (legs set right back on their body are great for swimming but leave them ill-equipped for terrestrial life) and they lay eggs in a scrape loosely furnished with aquatic vegetation. Although the nest may be built up in an effort to save eggs as water level rises, a rapid rise means failure. The breeding success of black-throated divers has improved markedly on some lochs, such as Loch Maree, where the provision of artificial rafts allows the nest to rise and fall along with the water level. Nevertheless, the diver must still contend with egg collectors, for whom a floating raft is an obvious target.

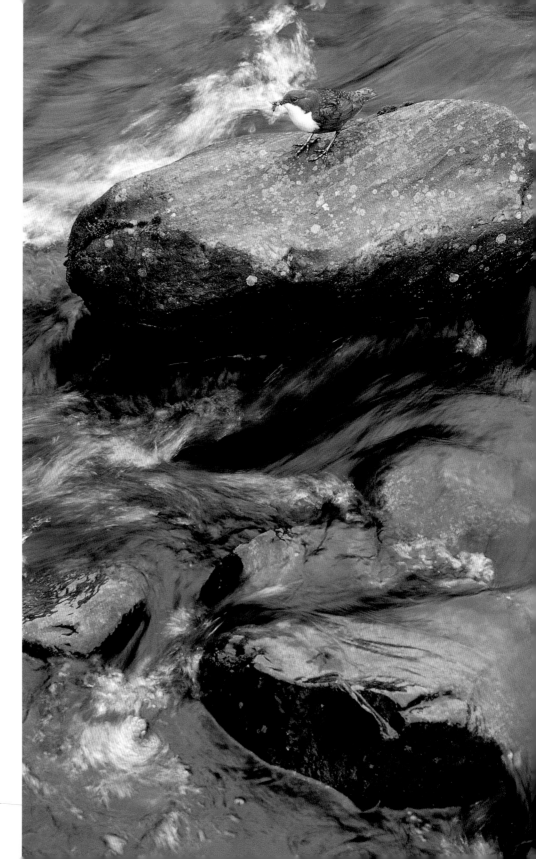

Many dippers choose to nest on man-made structures by the river, most commonly bridges.

Goldeneye

What has made the move into Scotland possible is the provision of artificial nest boxes, whose popularity was proven in Finland in the 1950s.

A male goldeneye scores a bright line across the pine-fringed loch as he scuttles away into the gloaming. It's early March. Up until the 1970s it would have been safe to assume that his partner would soon be heading back to breeding grounds in Scandinavia or Russia, perhaps to a nest hole high in a rotten pine. But since then the goldeneye has expanded its range into Scotland and maybe he is one of the hundred or so pairs that now nest here. While quite a few Highland lochs meet the goldeneye's particular requirements for open, cool water with little emergent vegetation and moderate depth, the surrounding forest normally fails on the provision of natural nest sites. Indeed, even in the wilder, more heavily forested parts of the duck's boreal range, there can be stiff competition for suitable holes – they need to be at least 9cm in diameter and with a chamber at least 45cm deep. What has made the move into Scotland possible is the provision of artificial nest boxes, whose popularity was proven in Finland in the 1950s.

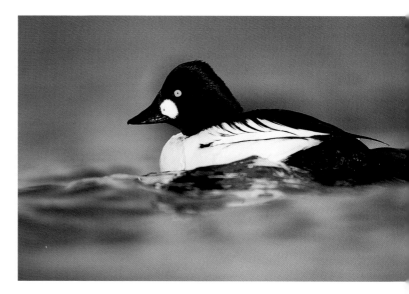

Paralleling the goldeneye's colonisation of our lochs has been the recovery of the pine marten population in the forests. Martens are tireless opportunists and soon discovered that nest boxes could provide not only eggs, but, on occasion, a brooding duck too. Pine martens are now the main predators of goldeneye in Scotland, to the extent that Forestry Enterprise has taken down its nest boxes by Loch Morlich since predation reached 100%. One study from Sweden using dummy eggs indicated that the distance the box was placed from the lakeside (natural sites can be more than 1km from water) made no difference to the level of predation so some form of anti-marten baffle may be the only solution to the problem.

Grey heron

At the moment herons are doing well in Scotland, recording a 113% rise in numbers between 1994 and 2002.

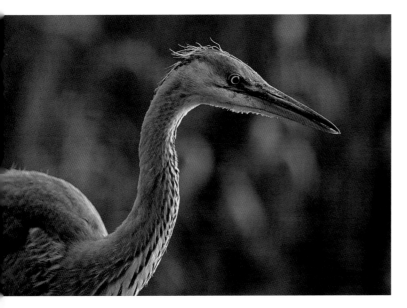

In Scotland, grey herons are seen as often along the coast as they are on inland lochs and rivers. In winter, the ice-free conditions provided by estuaries and shore lines can be crucial for a species that suffers up to 70% mortality of first year birds. The fishing skills that sustain them cannot be learned in a hurry so young birds are particularly prone to starvation.

Over a number of winters, from a hide sunk into its bank, I watched herons that used a pond near Montrose. Before dawn, the birds would fly quietly down from the fringing pines, by which time I was frozen into position. They were quite untroubled by the hide and even when I used a more obvious one in the mud at the edge of the pond, they continued as normal – on one occasion even coming over to peck the fabric. Herons spend a lot of time loafing, whether off-duty at incubation time, or simply waiting for the tide to fall. They are loyal to various loafing spots, often out in fields, making location of a hide easier. This pond was one such place. When it froze solid I followed the birds to the wrack-strewn margins of Montrose Basin, this time using an amphibious hide to get close.

While herons are unpopular when they stage raids on garden ponds (easily protected with netting), their impact on fisheries is usually tolerated and they endure much less persecution than other protected fish eaters such as cormorants. Nevertheless, they are still at risk when tall nesting trees are cut down. At the moment, however, herons are doing well in Scotland, recording a 113% rise in numbers between 1994 and 2002.

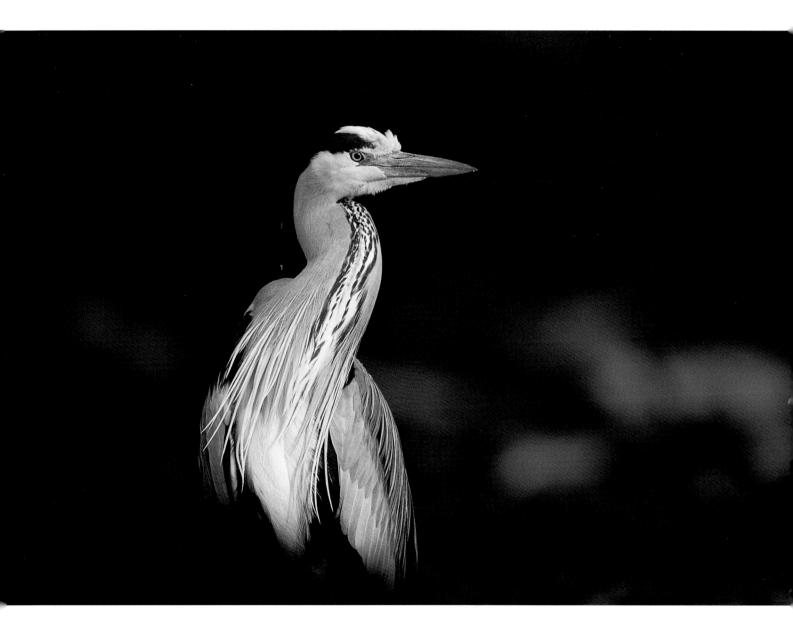

Lapwing

Lapwings feed mainly at night when the big earthworms that deliver the best reward for effort are active and nearer the surface

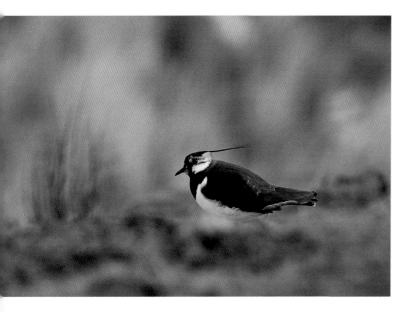

of tumbling and climbing, butterflying and diving, the male would scrawl an exuberant signature across the pallid spring sky, signalling a warning to others that this patch was his. And while crops in the fields of farms surrounding ours grew tall, the bare soil of the newly planted strawberry field provided the sort of open conditions favoured by the lapwings. The absence of livestock, however, probably meant that they went elsewhere to feed.

Lapwing eggs used to be collected for the table and only after the Lapwing Act of 1926 came into force did the population begin to grow steadily. Agricultural intensification later in the century, the switch to autumn-sown wheat and barley and the drainage of wetlands conspired to depress the population once more, especially in England and Wales. In Scotland, the lapwing now exploits a wider range of habitats, notably the Hebridean machair. Here though they have had to contend with predation by American mink and hedgehogs, declining in South Uist and Benbecula by 30% between 1983 and 2000.

Each April, we planted a new field of strawberries on the small farm in Angus where I grew up. The soil was brought to a fine tilth, the runners planted with a handfed machine then the field lightly rolled to firm them in. This was a very slow, meticulous job but the tedium was often relieved by the sight of courting lapwings prospecting the field. In a song flight full

Lapwings feed mainly at night when the big earthworms that deliver the best reward for effort are active and nearer the surface. One study has shown that lapwings can find three times as many large worms at night as during the day, when they just snack to keep hunger at bay.

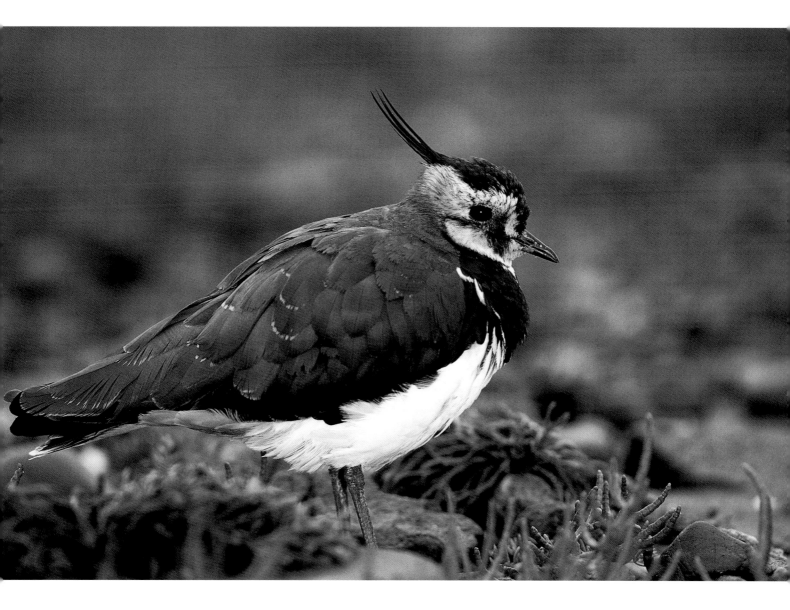

Osprey

About half the Scottish osprey population nests on artificial platforms of some sort, the remainder most often in mature pines.

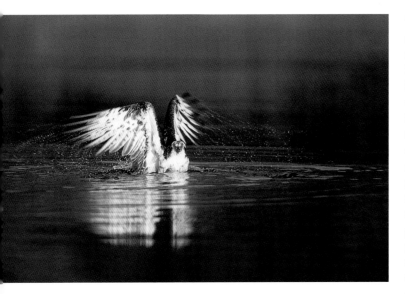

Of the three large birds of prey that made a return as breeding species to Scotland in the second half of the 20th century, only the osprey did it unaided. Programmes involving sea eagles and red kites relied on the import of quite large numbers of chicks, principally from Scandinavia, for subsequent release. The osprey, in contrast, recolonised naturally, famously nesting at Loch Garten in 1954 after an absence from Scotland of 38 years. There is now some doubt whether the bird ever became completely extinct as a breeding species and osprey authority Roy Dennis believes that they continued to nest discreetly at a few remote locations.

The osprey's early days were not easy. Following the successful season of 1954 in which two chicks were reared, egg thieves robbed the nest in 1955 and 1956. Round-the-clock protection for the Loch Garten site was introduced in 1957 but only one bird appeared amidst rumours that its mate had been shot in the vicinity. A pair returned in 1958 but their eggs were destroyed by vandals. 1959, finally, marked the start of annual breeding and the slow growth of the population. By 1976, there were still only 14 pairs (including one at the SWT's Loch of the Lowes reserve) but this had increased to 76 by 1991. Now, over 150 pairs return to Scotland annually and in 2001 two pairs bred successfully in England, for the first time in over 160 years. Nevertheless, egg theft continues to put a brake on population growth though not all sites are vulnerable to this form of persecution. About half the Scottish osprey population nests on artificial platforms of some sort, the remainder most often in mature pines. Four use the base provided by high-voltage electricity pylons and a platform just a few meters from a Trident missile store at the Royal Navy's Coulport base enjoys heavy military protection.

When unmolested, ospreys tolerate the presence of people and visitors to fish farms can enjoy fantastic views when the birds come in to fish un-netted ponds. Ospreys need to judge the size of fish they tackle carefully; their feathers are not waterproof and if the bird's talons get caught in the bones or scales of a fish that is too large to lift it is likely to become waterlogged and drown.

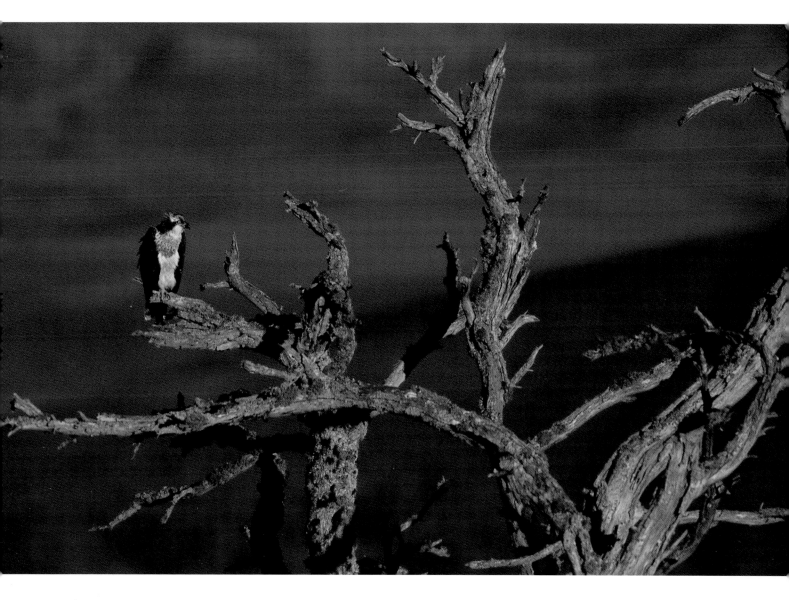

© Neil McIntyre

Common and wood sandpiper

On land, they are fidgety and restless, stalking and snatching at invertebrates, bobbing incessantly.

Unlike most other waders, the common sandpiper is primarily a fresh-water bird, returning to pebbly uplands rivers and streams in Scotland in late April after a winter in Africa. Its piercing, precisely articulated call notes are often the first indication of a pair on a river. This is soon followed by the sight of flickering wings as the birds arch low over the water. On land, they are fidgety and restless, stalking and snatching at invertebrates, bobbing incessantly. A scarcely concealed sense of panic is easy to imagine.

While common sandpipers nest in deep bankside vegetation, they readily use posts and stumps as calling posts, vantage points from which to chivvy intruders from a territory. In contrast, the much rarer wood sandpiper – the breeding population is only about 10 pairs – frequently uses low trees from which to call and launch short display flights. On occasion they even raise their young in abandoned thrush nests a few metres above the ground. In Estonia, using my amphibious hide, I have had little difficulty is stalking this species – along the muddy margin of a lake – to within 5 metres. But in the open bog – the sort of habitat the species is more likely to be encountered in Scotland – it is as anxious as the common sandpiper.

The wood sandpiper began to appear regularly as a breeding species in the 1960s but its numbers have remained extremely low and its breeding status precarious. There is the hope, however, that if or when the beaver is re-established in Scotland, localised flooding brought about by damming will improve the habitat for wood sandpiper and allow its numbers to increase.

Whooper swan

They are more likely than other swans to be encountered on farmland, where they feed on potato chats and grain left in stubble fields.

Until the 18th century, whoopers bred regularly on Orkney but today they nest only occasionally in Scotland. This swan is first and foremost a winter visitor, the bird of winter; clean white plumage relieved only by a spot of colour – on the bill – like a lingering birch leaf that refuses to fall.

The first arrivals reach Scotland from Iceland in early October. Normally the swans travel in family groups – parents with up to four cygnets from that year. They stay together for the winter and return north as a family the following spring, only to separate when they arrive back on the breeding grounds. Whoopers show up on all sorts of remote and tiny waterways, from ice-free bends on a highland river to flooded fields and larger lochs and estuaries. They are more likely than other swans to be encountered on farmland, where they feed on potato chats and grain left in stubble fields.

Why is it, when so many birds go to great lengths to be inconspicuous on their nests, that swans are pure white? They can be seen from a mile off. A combination of reasons has been suggested. Firstly, wild whooper swans are thought to remain loyal to the same partner for life, as captive birds are.

A strong bond develops that extends into co-operative defence of a nest site: two swans facing up to a predator are a formidable deterrent to all but the hungriest. What seems to be of more concern to the swans is competition with other swans for breeding territories; whoopers take a much larger area than mute swans and, importantly, are very intolerant of disturbance. White plumage is a good territorial marker, warning potential rivals for space to keep their distance. This message is reinforced by two white adults. Youngsters are a less obvious greyish brown, the only relief to their drabness coming in the pinkish base of their bill.

Although some individuals are approachable, most whoopers, especially in family groups, remain wary of people, taking sanctuary in the middle of frozen lochs or marshes. Perhaps this is how these ghostly northern visitors are best viewed: aloof and slightly mysterious.

Sea eagle

The fact that the last native population lived in the north west was more a measure of its remoteness than quality of habitat.

It's twenty years now since the first eggs were laid (on Mull) by sea eagles reintroduced to Scotland by the then Nature Conservancy Council, in 1983. The first phase of the project saw 92 young eagles brought from Norway and released on Rum between 1975 and 1985. A further 56 chicks came in between 1993 and 1998 and were subsequently freed in Wester Ross.

The first eggs failed, however, and it wasn't until the subsequent year that the first wild-bred chicks were fledged, 68 years after the bird's extinction in Scotland. Population growth has been slow – prior to 2003 only 13 out of 21 pairs had reared young and much of the success has been due to four pairs – but the summer of 2003 saw a change in their fortunes when 25 pairs fledged 26 young. This can be attributed in part to a mild preceding winter and fine weather during the breeding season. Nevertheless, this shouldn't mask the fact that west-coast release areas are less than ideal. There is much less prey available in the west than in the east and the fact that the last native population lived in the north west was more a measure of its remoteness than quality of habitat. Centuries of deforestation and mineral leaching of the soils have not only impoverished an already relatively unproductive landscape but also reduced the yield of the shallow, inshore waters, an important consideration for a bird that takes much of its living directly or indirectly from the margins of the sea.

Experience of the sea eagle in central, coastal Norway indicates the bird's willingness to live close to populated areas when left undisturbed – even in suburban situations. Were the Scots to display a similar degree of tolerance we could expect successful east-coast introductions. The land and sea there are more biologically productive. This results in more prey – in the winter, the Moray Firth is home to huge number of wintering sea birds. The Firth is currently under consideration as a new release site. The sea eagle has shown elsewhere that spectacular predators don't necessarily need remote places to live in. Whether the Scots can make space for it will be a real test of natural pride.

Bottle-nosed dolphin

About one third of the porpoise carcasses examined by pathologists were found to have died as a result of dolphin attacks.

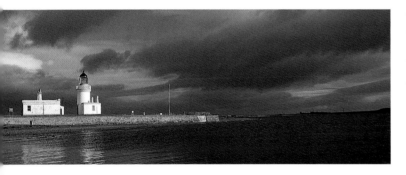

In Scotland, bottle-nosed dolphins are best known from the waters of the Moray Firth, but in fact they form a mobile population that moves up and down the east coast, ranging as far south as Arbroath and Montrose. Of the estimated £84 million generated annually from marine tourism in Scotland, a significant part comes from viewing cruises centred around the Moray Firth dolphins. The economy of Mull, where a wider range of cetaceans can be seen, receives a boost of up to £9 million per year from this form of eco-tourism. So, measures taken to conserve cetacean populations not only benefit the species concerned but also help to maintain rural employment, providing 385 direct jobs in 2001.

In the late 1980s and early 1990s, the early days of dolphin tourism, there were concerns about too many boats going too close to the mammals. As well as the risk of physical injury to the dolphins, they are known to move away from areas where they are harassed. Dolphin cruise operators are now encouraged (by means of an accreditation system) to sign up to the Dolphin Space Programme, a code of conduct devised by Scottish Natural Heritage and boat operators designed to minimise disturbance. Amongst its provisions, skippers are recommended to follow a regular route (so that the animals get used to a routine), to avoid mothers with calves, and to sail at a slow, steady speed, only coming to a halt if dolphins appear directly ahead. Any contact between people on the boat and the mammals – including feeding – is strongly discouraged.

The bottle-nosed dolphin, which in Scottish waters grows to about 4m and weighs 275kg, is not the fun-loving comedian commonly portrayed. The popular perception of dolphins is so firmly embedded that when video footage of a dolphin attacking and killing a harbour porpoise was obtained for the first time, it was broadcast on national television. One explanation of these events focuses on the infanticidal behaviour of some male dolphins, which try to kill a prospective mate's calf to bring her into oestrus more quickly. The more common harbour porpoises are about the same size as bottle-nosed calves and may present an opportunity to practise the skills needed to separate a bottle-nosed calf from its mother – and kill it. Between 1992 and 2002, about one third of the 410 porpoise carcasses examined by pathologists were found to have died as a result of dolphin attacks. Distressing though this may be, gill nets in the North Sea, set mainly by Danish boats pursuing sand eels, drown up to 8000 porpoises each year.

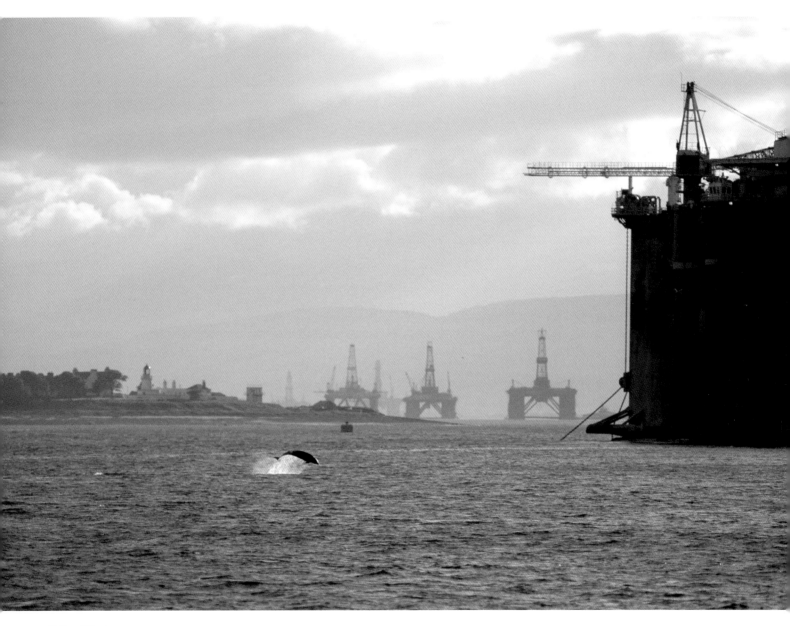

© Tom Walmsley

Hedgehog

Introduced to South Uist in 1974, hedgehogs now number about 5000, and have had a devastating impact on internationally significant populations of ground-nesting waders.

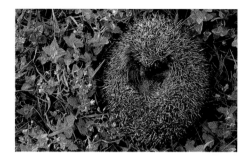

The hedgehog is a nocturnal feeder, snuffling round damp places on feeding rampages during which no slug or earthworm is safe. Gardeners who routinely put down slug pellets to protect their plants unwittingly rob themselves of a hard-working ally, one that has found it hard to adapt to the modern world. The Mammal Society's National Survey of Road Deaths in 2000/01 showed that up to 100,000 hedgehogs die each year on Britain's roads. Our gardens prove to be equally hazardous: hideous injuries inflicted by strimmers, slug-pellet poisoning, drowning in ponds (where there is nowhere to climb out) and entanglement in netting account for many lives each year. Others die when piles of leaves are burned during the hibernation period. Cattle grids, essentially large hedgehog traps, used to add to the toll, though most now feature an escape ramp. The tale of woe continues even when people try to help. Bread and milk put out by thoughtful householders, though filling, is indigestible and the hedgehog quickly loses condition. Cat or dog food is a much better option, though this can encourage less welcome visitors such as domestic cats, whose toll on wildlife, according to another Mammal Society survey, could be as high as 250 million victims a year.

Thanks perhaps to Beatrix Potter, the hedgehog is much loved in Britain, as demonstrated by the outcry when Scottish Natural Heritage announced plans to eradicate hedgehogs from North and South Uist and Benbecula, starting in 2003. Introduced to South Uist in 1974, hedgehogs now number about 5000, and have had a devastating impact on internationally significant populations of ground-nesting waders there, in particular snipe dunlin and ringed plover. A study into the likely consequences of moving them to the mainland concluded that up to half would die within six weeks of release and a further 20% of hedgehogs already living in release sites would die as a result of competition over food. Nevertheless, the British Hedgehog Society raised £50,000 to fund a relocation programme (although studies indicated that this exercise could amount to £250 per animal) to the mainland and Scottish Natural Heritage was asked to defend its science against hostile, not always very well informed, opinion. That first season saw the killing of 34 hedgehogs, while welfare organizations relocated a further 80. While such a stand off continues, the prospects for the wading birds of the Outer Hebrides remain poor. Perhaps the £50,000 donated by hedgehog enthusiasts might be better spent on ways to reduce road deaths.

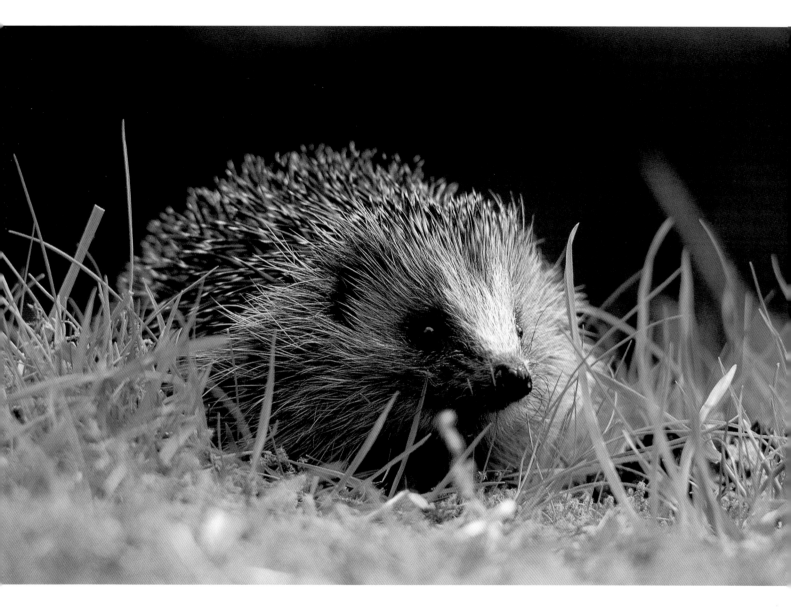

Leach's petrel

So reclusive is this small relative of the fulmar that ornithologists are unable to produce an accurate estimate of the world population and new colonies are still being discovered.

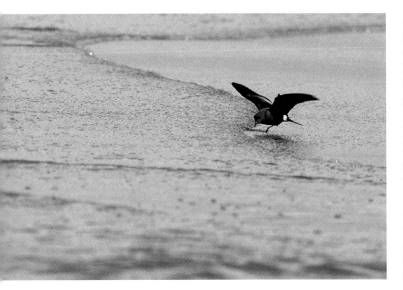

© Steve Young

Trying to find a dark sea bird smaller than a starling, whose chaotic flight gives the impression that it is tied to the wind, is difficult enough – but when it rarely alights and only ever comes ashore to breed on remote islands, the task seems next to impossible. Unlike its close relative, the even smaller storm petrel, Leach's petrel does not routinely follow boats, unless fish offal is on offer. The best chance most people have to see these birds is when they make nocturnal visits to their nest burrows

and crevices amongst scree. So reclusive is this small relative of the fulmar that ornithologists are unable to produce an accurate estimate of the world population and new colonies are still being discovered. There are thought to be about 49,000 pairs in British waters, with about 45,000 of those on St Kilda. This could represent 90% of the entire European population.

The seas where warm and cool oceanic currents meet tend to be highly productive as nitrates in the sediment are stirred up, nourishing phytoplankton, which feeds zooplankton and all the way up the food chain. The mixing of currents on the Canadian Grand Banks, for example, helps to support enormous numbers of seabirds in Newfoundland including, probably, several million petrels. In the eastern Atlantic, the Leach's petrel feeds mainly in shallower water near the continental shelf, sometimes staying quite near to breeding islands in summer. If colonies are to thrive, these islands must be kept free of alien predators such as cats and rats.

Studies from Newfoundland have revealed an unexpected hazard for these tiny seabirds: lighthouses. Although they feed mainly by day, at night petrels are attracted to the bioluminescent plankton of various crustaceans. It seems that this attraction to light extends to lighthouses, offshore oil and gas installations – even the bright lights used by squid fishermen. Collision and death inevitably follow.

Natterjack toad

Natterjacks favour dry lowland heaths and dune slacks, laying their spawn in shallow pools of brackish water.

Now found at only four locations in the south west, the natterjack toad is Scotland's rarest amphibian. Nationally, it is equally elusive with a total of 35 natural English sites. It is currently being translocated to suitable habitat in a bid to re-establish viable populations. Natterjacks favour dry lowland heaths and dune slacks, laying their spawn in shallow pools of brackish water. Huge tracts of heathland have been lost to housing and industry and in places where grazing animals are removed, the vegetation soon becomes too rank and shady to suit the natterjack. More importantly, this also encourages the entry of its main competitor, the common toad. Re-introduction projects must therefore have at their heart a plan to manage vegetation appropriately following release. A greater problem is the sea defences that are needed to protect coastal property. With them in place, the natural cycle of dune slack flooding is inhibited, making the dune slacks too dry for natterjack toads.

Male natterjacks call loudly at night during the breeding season, by inflating then deflating a throat pouch. While this and a yellow stripe down its back help to separate it from the common toad, the natterjack best distinguishes itself by an ability to run fast, in an action very similar to a speeded-up baby's crawl, which it does to escape attention. The colloquial name of 'running toad' is well deserved.

Chough

The key to the chough's decline is the loss of traditionally managed coastal pasture as farming has become more intensive.

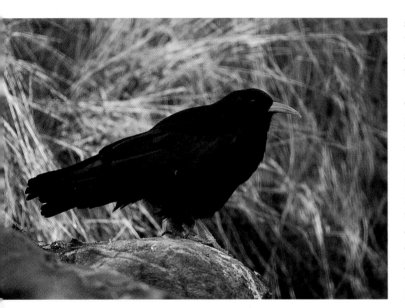

© Neil McIntyre

The waves that ram into Islay's west coast have a very long fetch and are a terrifying sight when pursued by a ferocious westerly. In Saligo Bay, metre-deep rafts of foam build in one corner of the beach where a peaty burn empties into the sea, quivering in a gale like grey blancmange. Behind the beaches, tatters of wrack, dry and blackened, are hurled onto pasture stung short by the salty air, and cropped close by rabbits, sheep and wind. As a counterpoint to the sound of massive waves crumpling

against the shore, a high, springy call – a bawdy version of the urban jackdaw's more clipped greeting – ricochets around the sky. The group of choughs testing the gale completes the wildness of the scene.

Once a relatively common coastal bird, the chough's British population has fallen to about 340 pairs, although Ireland still hosts over 900. The European population as a whole, numbering between about 12,000 and 17,000 pairs, is highly fragmented, increasing the chance of localised extinction. Most of the Scottish birds are concentrated on Islay and Colonsay, where special measures are in place to try to maintain their numbers. The key to the chough's decline is the loss of traditionally managed coastal pasture as farming has become more intensive. Unlike other crows, they are specialised feeders, relying heavily on the grubs and larvae associated with traditional pasture. Chemicals that reduce the number of these animals, such as anti-parasitic livestock drugs, can have a harmful knock-on effect on the chough too.

While choughs naturally nest in caves and sea cliffs, on Islay they readily take to abandoned outhouses and farm buildings. Farmers and others with nesting choughs are encouraged to renovate sympathetically. In Wales about 5% of the population now nests on artificial platforms set on sea cliffs and in mine shafts, raising the hope that on Islay too, choughs can be lured back to a more natural setting, facing the Atlantic.

Razorbill

Berneray and neighbouring Mingulay host the UK's largest congregation of breeding razorbills.

The razorbill is the closest living relative of the great auk, which stood somewhat taller than its extant cousin and shared a similar bill shape and plumage but, to its ultimate detriment, was flightless. The great auk too lived on St Kilda, where about 2500 pairs of razorbills live now, although it probably disappeared from there long before the last pair were killed in 1844 on Eldey, Iceland. It was just too useful – and easy to kill – at a time when people in Europe regularly starved.

The National Trust for Scotland properties of Berneray – the very last island in the archipelago of the Outer Hebrides – and neighbouring Mingulay host the UK's largest congregation of breeding razorbills – around 17,000 pairs. Those on another property, Canna, suffer heavily from predation by brown rats. Razorbills use a wider range of nest sites than the closely related guillemot and can even be found in disused rabbit or puffin burrows. In Greenland, they have been recorded nesting as far as 300m from the sea. Crevices or wide ledges with an overhang to form a roof are the most popular locations, though. Some of the alternative nest sites leave them especially vulnerable to rats so The National Trust for Scotland plans an eradication programme in the winter of 2004/5 to improve the prospects for razorbills and Manx shearwater the following season. A similar programme on Ailsa Craig has brought many benefits for the seabirds there (see Brown/Black Rat, p. 68) – and, in contrast to the hedgehog programme (see p. 114), no popular campaigns to re-settle the rats on the mainland!

While the British population of razorbill seems to be doing well, they are as vulnerable as other pelagic birds to changes in ocean currents affecting the supply of sand eels, and are susceptible to drowning in trawler nets and chemical pollution. But at least they need no longer fear hungry islanders or ruthless skin collectors.

Oystercatcher

The female calls the louder, deeper notes, the result of having a longer trachea which, were it to be straightened, would be twice the length of her neck.

Oystercatchers may protest frantically whenever people come near but that doesn't deter them from nesting close to us when the site is right. I've seen nests in strawberry rows, hollow strainer posts, on gravel tracks and even in the middle of a busy roundabout. Leaving this last site must have been especially hazardous for the chicks.

In most parts of continental Europe they remain closely associated with the coast but in Scotland they are as familiar along rivers and burns in the eastern glens as they are on the Hebridean shore. Further afield, they are spreading into quite intensively managed landscapes in East Anglia and the Vale of York and it is this adaptability that has allowed the population to grow to about 33,000 breeding pairs, the majority of which are in Scotland.

Some nights, lying in my campervan parked by a sea loch, I imagine that I hear a dozen oystercatchers flying around. But a glance outside will reveal just three or four complaining about a hooded crow; their voices have a remarkable ability to propagate. The female calls the louder, deeper notes, the result of having a longer trachea which, were it to be straightened, would be twice the length of her neck.

In winter, Britain is host to about 360,000 oystercatchers representing roughly 45% of the European population. Many of these migrate from the Faroes, Iceland and Norway, flocking to ice-free estuaries, especially those rich in cockles and mussels.

Puffin

St Kilda is by far the largest British station, with around 136,000 pairs.

The puffin is the most abundant auk of the north Atlantic, with an estimated population of around 5 million breeding adults supplemented by many non-breeders. In truth, counting this burrow-nesting bird is extremely difficult and apparent fluctuations in the past may be attributable to evolving methodology rather than actual variation. St Kilda is by far the largest British station, with around 136,000 pairs – roughly 30% of the UK population. Mingulay and Fair Isle are important too with at least 4000 and 40,000 pairs respectively. There is a certain amount of out-migration from population centres as evidenced by the rapid growth of the Isle of May colony. Five pairs nested for the first time there in 1959. By 1982, there were 10,000 pairs. The annual growth rate of 22% between 1973 and 1981 could only have been sustained by immigration to the island.

In Scotland, puffins return to their cliff-top colonies in late March/early April after a winter on the high seas. The best time of day to encounter them on land is mid-afternoon and evening. If they are not occupied incubating, they raft on the sea for some of the day then stage several flypasts before deciding to settle on particular tussocks or flat rocks with other puffins. Puffins use subtle body language to communicate with other members of the group, the nuances of which become apparent after long observation.

Some of the largest colonies are found in Iceland where the subsistence tradition of hunting puffins for the table continues, with little apparent impact on the population. Birds carrying

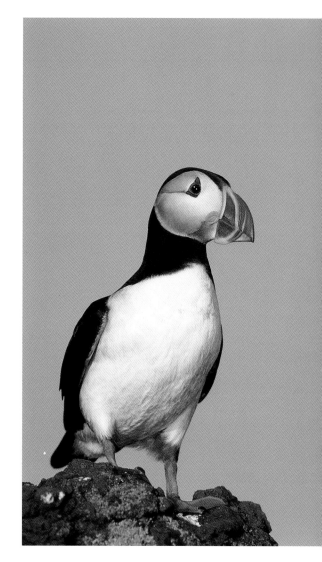

sand eels, and therefore feeding young, are spared the Icelandic pot. The St Kildans too made heavy use of the birds for meat and feathers and in one year alone, 1876, a harvest of over 89,000 puffins was claimed.

Otter

The almost universal affection in which otters are held in Britain – for which Henry Williamson and Gavin Maxwell must claim some of the credit – is not shared throughout Europe.

Tumbles of boulders on the upper shore provide secure, undisturbed sites for holts, and their other main territorial need is a source of fresh water for drinking and bathing.

Photographing wild otters is quite a challenge. I positioned myself (well away from the nearest holt) in a crevice at water level, close to where I expected the animal to come ashore. The otter swam nearer, hindered by its catch, surfacing and submerging. Then, thirty metres out, it changed course and headed directly towards me. Out of sight. Bubbles. I could see the tip of its tail 15 metres away. It was too late to move. The water calmed for a moment then the otter surfaced a couple of metres from me. In under a second, it blinked, opened its nostrils and smelt something very unpleasant. There was a gulping grunt and spray as its tail thrashed the water. I didn't get the photo and didn't mind; some experiences just can't be shared in pictures.

Through binoculars, I scanned the glass-calm sea loch for two hours before I saw the otter. Its wake pointed like a silver arrowhead towards the shore, aimed near my seaweed nest by the water. Otters that fish in the sea eat small catches while afloat, chewing with their pink mouths wide open, but they bring bigger prey ashore to devour.

Unlike their lowland riparian cousins, otters living around the sea lochs of the north and west are frequently seen by day and, when there is no wind, can be spotted from a long way off.

The almost universal affection in which otters are held in Britain – for which Henry Williamson and Gavin Maxwell, authors of *Tarka the Otter* and *Ring of Bright Water* respectively, must claim some of the credit – is not shared throughout Europe. In the Czech Republic, for example, they are viewed as unsympathetically as American mink are here, in spite of their indigenous status. It remains to be seen if our devotion to the otter remains constant as they continue their recovery and re-establish themselves as (second) top predator on lowland rivers throughout the country.

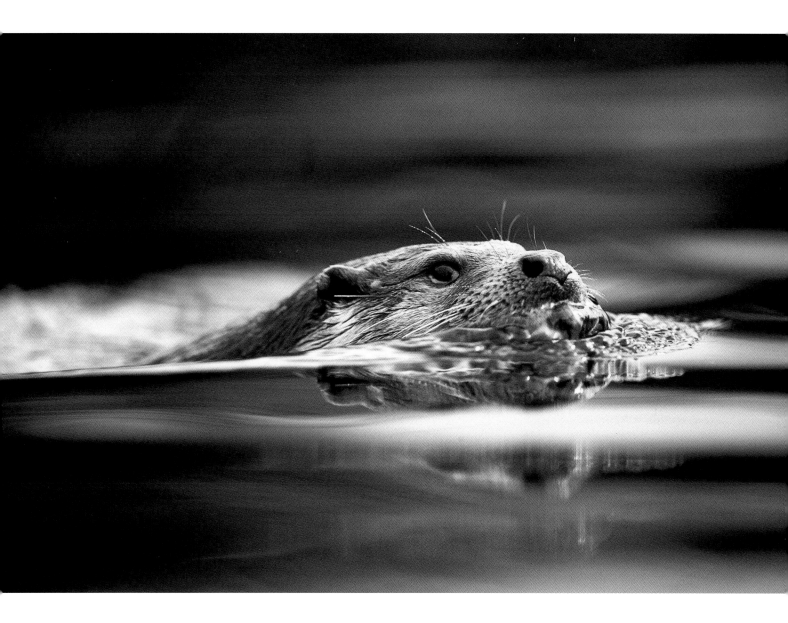

Common seal

The common seal is more likely than the grey to be found exploring the lower reaches of rivers and hauling out in quiet harbours.

Of the two seal species resident around our coasts, the common seal is the more comfortable with people. Its alternative name, the harbour seal, hints at its tolerance and it is more likely than the grey to be found exploring the lower reaches of rivers and hauling out in quiet harbours.

Common seals are masters of energy conservation and, when they are not feeding, they spend hours in contemplative repose.

A comfortable layer of insulating blubber, at its thickest in spring, cushions them as they lie on angular rocks. At close range, it is easy to see the V-shaped nostrils that distinguish this species from the more numerous grey seal, and the contrast between the common's more dog-like face and the grey's Roman profile.

Common seals pup during June until mid-July. The pups can swim within a few hours of birth, helping them to avoid predators. In contrast, the grey seal's pups are land-bound for the first three weeks of their lives and rely on the isolation of their off-shore islands for protection. It was mainly common seals that succumbed so disastrously to the phocine virus, a disease similar to canine distemper, in a late 1980s epidemic that killed over 50% of the seals in some European colonies and an estimated 6% of the Scottish population of around 20,000. Similar epidemics were documented in the 18th and 19th centuries, before the North Sea became so badly contaminated, and an outbreak in 2002 claimed at least 800 seals, the majority, once again, common seals.

Where seals are used to people coming and going, they may tolerate quite a close approach. I was surprised once, however, to see a golden retriever on Islay amble to within 10 metres of a hauled-out seal, bark at it a few times, then continue to follow its nose along the shoreline. The seal, though a little startled, made no effort to shimmy back into the sea.

The common seal's more dog-like face contrasts with the grey's Roman profile.

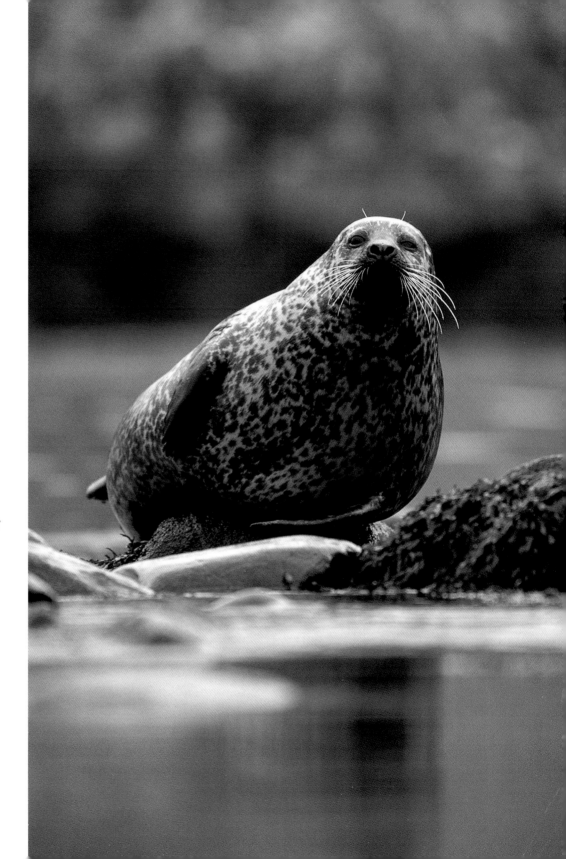

Grey seal

Several islands such as Mingulay saw an end to permanent human settlement in the 20th century, providing the animals with prime, undisturbed breeding locations.

To most people the grey seal is cute, cuddly and (quietly) charismatic, but others see it as a direct challenge to their livelihood. Almost half the world's population of grey seals live in the water around our northern and western shores and a five-fold increase since the mid-1960s in some Western Isle populations is viewed with dismay by many fishermen.

Seals have had something of a rollercoaster history in Scotland. After they were hunted to fewer than a thousand, protective legislation in 1914 helped their numbers to grow rapidly. Crucially, several islands such as Mingulay saw an end to permanent human settlement in the 20th century, providing the animals with prime, undisturbed breeding locations. Today it is possible to encounter over 1000 adults hauled up on Mingulay's beaches in winter, though they do not breed there. With a plentiful supply of fish and freedom from disturbance, numbers have burgeoned to the current estimate of about 100,000. About 38,000 pups are born in Britain each year, and about half of them see their first birthday.

Seals, both common and grey, used to be notorious for their predation of salmon caught in stake nets, particularly on the east coast, though most of these netting stations have now been closed down as the stock of wild salmon dwindles. In a curious twist, the bodies of more than 40 grey seals were washed ashore in Orkney in early 2002, probably killed by orcas. Many whales – and seals – had been attracted to the area by thousands of salmon escaped from a fish farm.

The real conflict at the moment is with the trawlermen. More seals eat more fish, yes, but do they pose a greater threat to industrial fishing than it does to itself? Or is the grey seal simply an obvious scapegoat for declines brought about by over-exploitation, as some conservationists claim? The EU's response has been not to call for a massive reduction in the seal population but to impose severe restrictions on the catching effort. Whatever the truth, the grey seal joins a long list of others including the pine marten, otter and peregrine whose popularity seems to decline with their recovery from endangered status.

Arctic tern

The economy of Fair Isle, for example, is heavily reliant on eco-tourism.
Take away the birds and for many people the reason to visit is gone.

The arctic tern must be the ultimate sunseeker. Enjoying summer in both hemispheres, it breeds on shingle beaches as far north as the high Arctic and spends the remainder of the year along the edges of the Antarctic pack ice. Scotland is home to about 90% of the UK's breeding arctic terns, the majority of those on Orkney and Shetland where colony sizes and productivity fluctuate greatly from year to year. In Scottish waters, arctic terns are heavily reliant on the sand eel – a high-energy food source for chicks and adults alike – and breeding success mirrors its population dynamics. The waters around Fair Isle, where ideal depths (less than 80m),

ocean-floor composition and strong currents coincide, seem to provide perfect conditions for spawning sand eels, accounting for the vigour of nearby seabird colonies – which include over 1000 pairs of arctic terns on Fair Isle itself.

But in years when there are few sand eels, it is a very different story. In the first three years of the 21st century, sand eel stocks across the North Sea collapsed, not for the first time, thinning the numbers of dependent sea birds in Shetland and elsewhere. Changing ocean currents and sea temperatures and the consequent decline in plankton production are known to vary sand eel numbers but the effect of commercial exploitation may also contribute to the continuing depression. The biomass of sand eels in the North Sea appeared to grow massively in the 1960s and 1970s, perhaps because of over-exploitation of predators such as cod and mackerel and competitors like herring, to the point that it became an attractive target species. The Danes currently have a total allowable catch of 1 million tonnes per annum of sand eels from certain sections of the North Sea but in 2003 failed to catch even half of that. While this may be seen as good news for seabirds, it reflects the parlous state of sand eel stocks and the need to protect those in the most productive areas. This is not merely for the benefit of birds; the economy of Fair Isle, for example, is heavily reliant on eco-tourism. Take away the birds and for many people the reason to visit is gone. But if short-term fluctuations in ocean currents become long-term patterns, no amount of fishing restraint will bring the sand eels back.

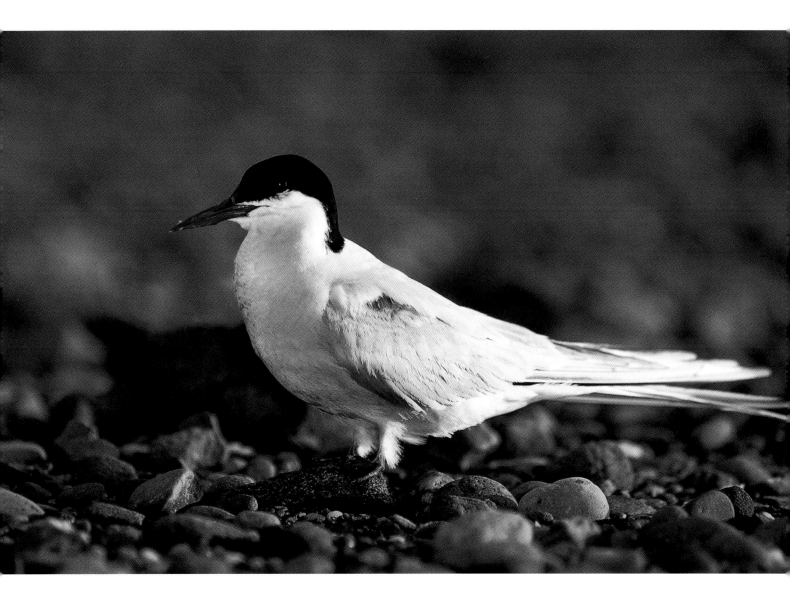

Eider

Some females are known to 'kidnap' ducklings to afford better protection for their own youngsters, keeping the other females' broods on the fringes of her own so that they are more likely to be taken in a predator attack.

These sea ducks are highly gregarious not only in the sheltered estuaries where they display in spring but even on land where they nest. At the Royal Navy's base at Coulport up to 81 nests in an area 90 by 25 metres have been recorded. The drake helps in the selection of a nest site, but the duck is responsible for incubation and care of the ducklings. Her mottled brown plumage makes her hard to spot. During the short times she leaves the nest, the eggs are covered with the soft, warm down plucked from her breast. Yet by nesting in high concentrations, eiders do attract the attentions of predators. A dog running wild amongst a colony may panic some birds into an incautious departure from their nests – and a quick snack for ever-vigilant gulls and crows. One of the largest colonies of eiders in the country, at the Sands of Forvie National Nature Reserve north of Aberdeen, suffered an almost total breeding failure in the 1990s, due largely to predation by foxes, gulls and crows.

If the eggs make it through to hatching (although laid days apart, they hatch within hours of each other), the little black ducklings face a perilous dash to the safety of the sea, during which time they are especially vulnerable to gulls. Once in the water, however, they do what eiders do best: get together with others. Creches form when many broods of chicks from unrelated families gather, closely supervised by a few females who provide early warning of approaching predators. Indeed, some females are known to 'kidnap' ducklings to afford better protection for their own youngsters, keeping the other females' broods on the fringes of her own so that they are more likely to be taken in a predator attack. Creching – whether voluntary or enforced – is a feature of a dense breeding population and individual creches may number up to 100 ducklings.

The eider's diet consists principally of crustaceans and molluscs, particularly the blue mussel, and this sometimes brings it into conflict with shellfish farmers on the west coast and in the northern isles. Licences have been issued to kill eiders attacking mussel lines in the west but Shetland Islands Council includes a clause in its licences which permit only non-lethal deterrents. Research into the most effective method is ongoing.

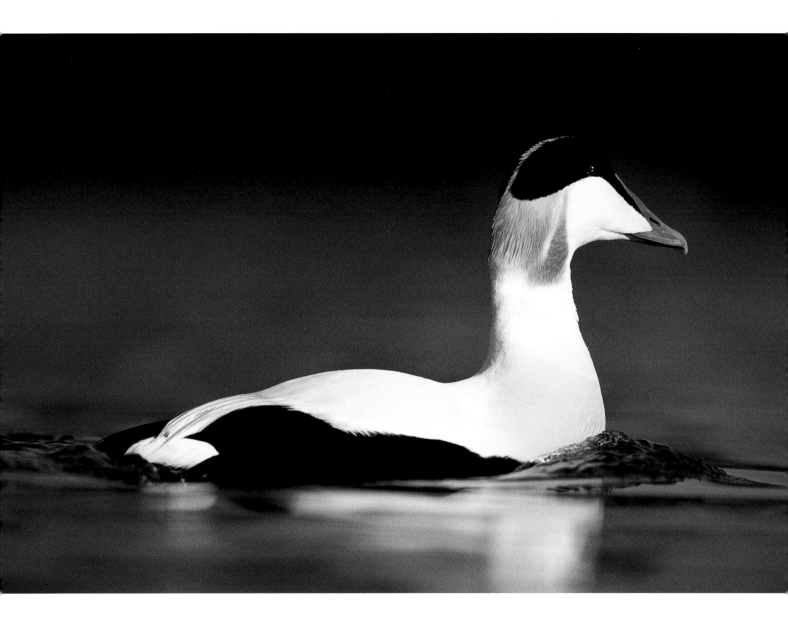

Northern fulmar

From the cliff top I can see other fulmars silently riding the updraughts, flying in figures of eight as they survey the neighbourhood.

On the cliff top, the two courting fulmars break off their wooing to follow me with deep, dark eyes as I settle down nearby. Their heads turn slowly to and fro, waiting for me to make a move, but I sit tight in the chill February breeze hurrying in off the North Sea. Once satisfied that I pose no threat, they resume their cackling and head-waving. The chances are that they know each other already; fulmars are monogamous and maintain their partnership over a number of seasons.

The colonisation (or more accurately, re-colonisation) of Scottish coasts by fulmars is quite a recent phenomenon. Archaeological evidence from Skara Brae indicates that the fulmar was present in Orkney during the Neolithic era, but over time its British range contracted until it lived only on St Kilda. An increase in the area of warm water in the north-east Atlantic, the result of subtle climatic changes that began in the 17th century, improved the availability of natural food. This, along with the growth in whaling – then deep-sea trawling – drove the population expansion after the 1870s. St Kilda, numbering 67,000 nests in 1999, remains Britain's biggest colony, representing 13% of the British population.

Fulmars are related to shearwaters and petrels and are a northern hemisphere counterpart of the albatrosses. Superficially, they look like gulls but their stiff-winged flight is an instant giveaway. From the cliff top I can see other fulmars silently riding the updraughts, flying in figures of eight as they survey the neighbourhood. At this time of year, the fulmars have the cliffs to themselves. Unlike most other seabirds, fulmars are loyal to their breeding sites for most of the year. They disappear out to sea for two or three months in the autumn and then again for a couple of weeks before egg-laying but for the rest of the time are always nearby, spending the night on the sea outside the breeding season.

The female fulmar may not lay her single egg until mid or late May. She and her mate (like other shearwaters) then have a long period of incubation to share – about 52 days. The combination of a single chick and lengthy incubation is a high-risk breeding strategy, leaving no time for a replacement egg if the first is lost late in the cycle to predators or bad weather. For the first two weeks of its life, the fulmar chick is rarely alone. Any predators, such as peregrines or rats, attempting to snatch it or to go too close are met with a carefully directed stream of stomach oil from the parent or chick. Indeed, fouling by fulmars is blamed for the disappearance of the peregrine as a breeding species in Shetland. As well as clogging up feathers and fur, the oil is vilely pungent and anyone getting it on their clothes is well advised to throw them out.

Fouling by fulmars is blamed for the disappearance of the peregrine as a breeding species in Shetland.

Northern gannet

The long incubation of about 44 days yields a black chick so unprepossessing in appearance that it is hard to credit it can develop into a handsome adult gannet.

Perhaps the most impressive avian spectacle in Britain is the Bass Rock gannetry in the Firth of Forth. Although there are larger congregations of gannets elsewhere (Boreray and the Stacs in the St Kilda archipelago, with 60,000 gannets, hold about 24% of the world population), few are as accessible as the Bass (about 20 minutes by boat from North Berwick) and no others offer the possibility of being so close to so many wild birds.

Gannets are streamlined, goose-sized birds equipped with a hefty bill to catch mackerel and herring when they dart into the sea. On the narrow path that runs over the top of the Bass, the unwary visitor may feel the point of a bill as birds nesting within centimetres of the trail jab unwanted legs out of their space. As the number of gannets has risen (the UK population is something over 200,000 pairs), so less favoured spaces beside the path walked by hundreds of visitors annually are occupied.

The long incubation of about 44 days yields a black chick so unprepossessing in appearance that it is hard to credit it can develop into a handsome adult gannet. The solitary youngster spends an extraordinarily long time in the nest. When it fledges in August or even September as a fat 'guga' it weighs more than its hardworking parents, who may have ranged up to 65km a day in search of food for it. Gannets were a staple food of the St Kildans and although they are no longer hunted there, the traditional harvest of about 2000 guga by men from Ness continues on Sula Sgeir off Lewis every August.

Research by Aberdeen University has shown that as well as sustaining the St Kildans, gannets may also have played a part in the ultimate demise of the community. Soil samples taken from fields used for grazing and midden pits revealed high levels of toxic heavy metals, including arsenic, cadmium and zinc, the result of using the bodies of seabirds to fertilise the land. These findings help to explain why crop productivity declined after the mid-18th century, as these pollutants accumulated in the soil.

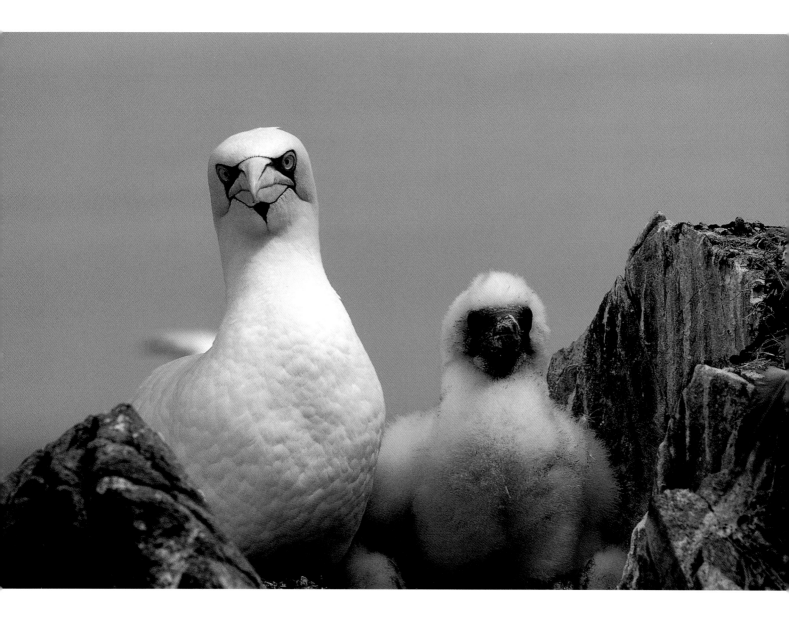

Great skua or bonxie

Great skuas invite anthropomorphic comparison. It is easy to read menace into their demeanour and a motive beyond survival.

It's a brisk May morning on Hirta, the main island in the St Kilda archipelago. Under a load of equipment, I make my way up An Lag for a view from the Gap across to Boreray. In the shadow of the hill there is a small gang of bonxies, not yet on eggs, that has watched my slow progress. Later in the season they would dive-bomb without hesitation. When I go to see what two of them are eating, they simply move back a little, dark, sinister and silent. In this wild place, their home not mine, such a silence could be taken as an appraisal. Their victim was a puffin, the neck eaten first. Later I saw two tackle a gannet, taking one wing tip each and forcing the bird to disgorge its cropful of fish.

Bonxies have a voracious appetite and a joint study in 1996 between Glasgow and Durham Universities concluded that St Kilda's 213 skuas accounted for 12.2 tonnes of fish, 1.6 tonnes of goose barnacle and 8.8 tonnes of other seabirds that year. Leach's petrel numbers have declined on St Kilda by 48% between 1999 and 2002: bonxies, killing up to 14,000 of them a year, are the prime suspects.

Great skuas invite anthropomorphic comparison. It is easy to read menace into their demeanour and a motive beyond survival.

But these 'thugs' are simply good at doing what they evolved to do. The great skua's origins are unclear. Some believe that a few birds from the southern hemisphere travelled north as shipping traffic across the equator increased, founding colonies in the north Atlantic. By the late 18th century, the first few pairs had started to nest on Shetland but later Victorian skin collectors kept the growing population in check. Protection began in the 1890s, enabled numbers to double every 10 years until the 1970s when they slowed down. Today, about 60% of all breeding great skuas nest in Scotland – roughly 8500 pairs, concentrated on Orkney and Shetland, with some mainland sites in the north west and a number of western isles, including Handa and St Kilda.

The bonxie's expansion of range and population has paralleled that of industrial-scale fishing with its byproducts of fish offal and undersized fish. But the great skua, like many other sea birds, also relies directly on sand eels and any depression in their numbers is reflected in the skua's. Nevertheless, they are adaptable scavengers/predators quick to colonise new territory. Bonxies are now appearing regularly as far south as Stonehaven, where one or two non-breeders patrol the huge seabird colonies in mid-summer.

The great skua, like many other sea birds, also relies directly on sand eels and any depression in their numbers is reflected in the skua's.

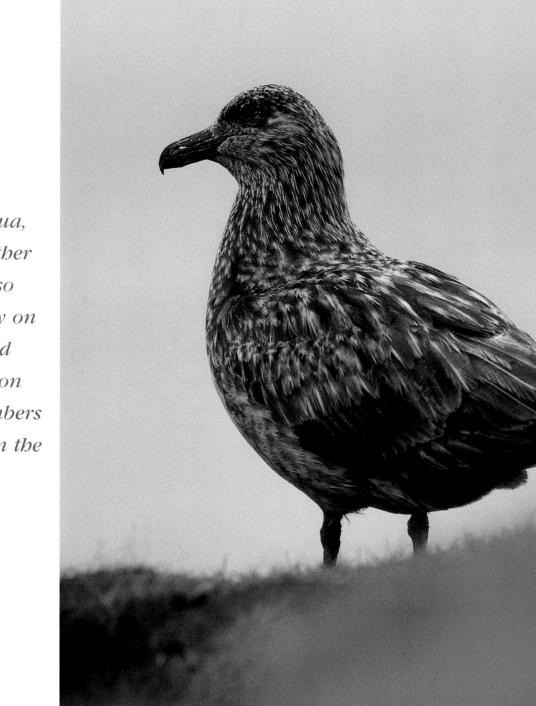

Black guillemot or tystie

These birds can hardly be considered gregarious – they don't go in for the cheek-by-jowl intimacy of their close relatives.

It was still early morning when a pure, thin, drawn-out whistle lured me along the ramshackle pier. It looked like a scrap yard and between the dismembered clutch mechanisms and ruptured gearboxes were views of the oil-smooth sea below. By this time I could hear whirring wings below my feet; it seemed the pier was being used as a roost site. Then, just eight metres away, between rusty 45-gallon drums, I saw the sirens: an association of black guillemots. These birds can hardly be considered gregarious – they don't go in for the cheek-by-jowl intimacy of their close relatives, preferring instead to know that they have neighbours, but at some distance. The pier was obviously a great attraction – not least, I imagined, because few people ever ventured along it.

I slowly stalked one bird, reassured by its tolerance as I approached to within 6 metres. When it turned to me and called it revealed a gorgeous vermillion gape, the same shade as its legs. Soon after I had taken the pictures, the irate owner of the pier called to me in a manner that made me think he was more concerned about the loss of car parts than disturbance to the tysties.

The species has a circumpolar distribution, breeding as far north as the high Arctic, but is less common than other North Atlantic auks and in a number of locations is vulnerable to predation by feral mink. Its distribution is determined to some extent by access to shallow seas; it rarely dives deeper than 20 metres. Various National Trust for Scotland properties, including Unst, Mingulay, Iona and St Kilda, host small breeding populations.

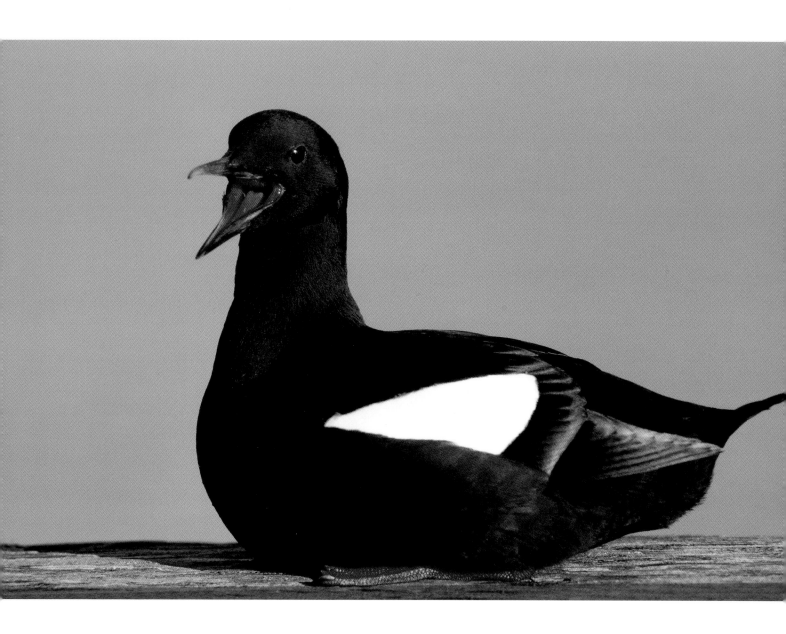

Guillemot

Guillemots have the most unfavourable body mass to wing area ratio of any bird that can actually fly, though that doesn't discourage them from making round trips of several kilometres to bring back a single fish to their chicks.

Going one better than their southern hemisphere counterparts, the penguins, guillemots are not only expert divers but can still fly, if only just. Their short wings allow them to pursue swift fish to depths of 50m, but are less well suited to prolonged flight, giving it an air of frenzy. Guillemots have the most unfavourable body mass to wing area ratio of any bird that can actually fly, though that doesn't discourage them from making round trips of several kilometres to bring back a single fish to their chicks. In the post-breeding moult phase, when the birds lose all their flight feathers at once, they gain weight to the extent that they could not fly even with a full complement of feathers. The balance between diet and mobility is a delicate one throughout the guillemot's life. Birds tend to collide with, rather than land on, their nesting ledges and eggs are heavily tapered at one end, reducing the likelihood of them rolling over the edge. Guillemots endure the highest nesting densities of any bird, with up to 20 pairs on a square metre of rock ledge, but nevertheless maintain their footprint-sized territories aggressively.

National Trust for Scotland properties host, in total, about 13% of the British population of guillemots, including about 40,000 at St Abbs and 37,000 on Fair Isle. Britain and Ireland between them have in excess of 800,000 pairs out of a total North Atlantic population of about two and a quarter million. Counting sea birds on cliffs is an imprecise science, and an almost impossible one when they are dispersed at sea in winter, though photographic surveying has proved to be quite effective. It is hard to be certain about population trends though it is evident that when there is a shortage of sprats the mortality of birds in their first winter rises steeply. Drowning in fishing nets is suggested as one of the biggest non-natural threats to guillemots in northern European seas, where deaths from this cause alone run into tens of thousands annually.

With about 40,000 pairs of guillemots, the RSPB's reserve at Fowlsheugh near Stonehaven is one of the most important mainland colonies and has the advantage of being accessible at any time of day. I prefer to arrive before first light in summer, to see birds silhouetted against an orange, blue and black sea. Some guillemots nest near the top of the cliffs and at close range in the early sun their heads and necks look as smooth as milk chocolate, their gape an orange filling. Only the stench of guano puts me off the thought of breakfast.

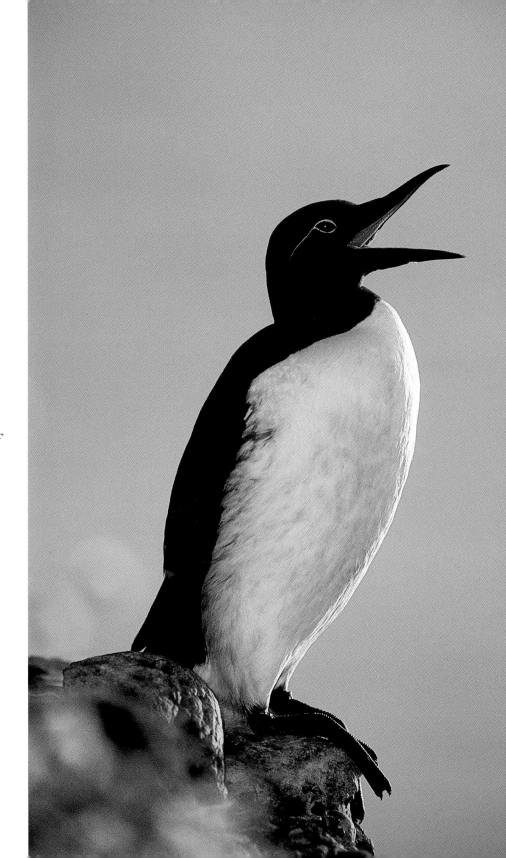

Guillemots endure the highest nesting densities of any bird, with up to 20 pairs on a square metre of rock ledge, but nevertheless maintain their footprint-sized territories aggressively.

Kittiwake

Kittiwakes readily take to man-made structures so long as they are left in peace.

More than any other gull that nests in Scotland, the kittiwake is a pelagic bird, spending winter far out at sea and returning to our shores only to breed. They can disperse quickly, as proved by one fledgling ringed on the Isle of May that was recovered in the autumn of the same year on Newfoundland. While they are most familiar on cliff lines, given a suitable platform kittiwakes readily take to man-made structures, such as the ruined Dunbar Castle, so long as they are left in peace. Legal protection in Britain and other countries bordering the North Sea has helped the kittiwake to expand its range during the 20th century from its strongholds north of the Arctic Circle. Britain and Ireland currently host about 540,000 breeding pairs; a further three million pairs occupy the cliffs of the Faroes, Norway, Iceland and Svalbard. Fair Isle has about 18,000 pairs and Mingulay a further 9000, but the largest British colony is on Humberside at Bempton and Flamborough Head, where the last census counted over 80,000 pairs.

The growth and decline of kittiwake colonies is usually linked to food availability, in particular the relative abundance of sand eels. A study in Shetland in 2000 showed that a scarcity of sand eels caused an 80% pre-fledging mortality; at least 25% of chicks have to leave the nest for a population to maintain its current level. In some parts of the North Sea, intensive human exploitation of sand eels – crucial not only for seabirds but for predatory fish such as cod – has been blamed for their disappearance, but there are additional factors that regulate the production of these small fish. They feed on microscope sea life – plankton – whose own distribution and abundance is affected by changes in sea currents and surface temperature – processes in turn influenced by global climate change.

At some locations, kittiwakes nest near the top of cliffs and it is possible to approach them to within a few metres without causing disturbance. Their head and belly is a brilliant white; the back and wings, military grey. Unlike herring gulls, they are not confrontational and tip quietly into the wind when they have had enough attention.

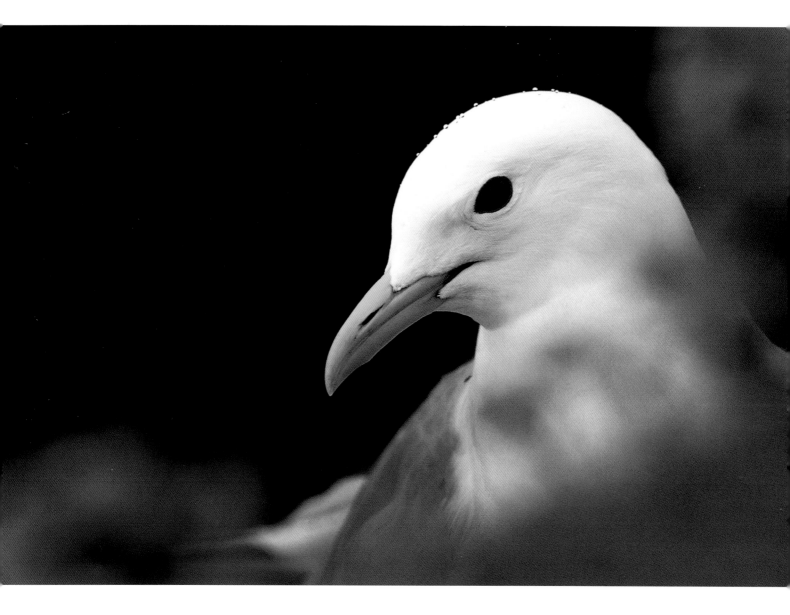

Acknowledgements

I am grateful, first and foremost, to my late father, Donald Benvie, who taught me to respect the land and fired a passion for the natural world that is a life-long gift. The late Gordon Burgess set me on the road as a photographer, an activity that has allowed me to remain in close contact with the land and provided a living along the way.

Duncan Halley has not only given support and friendship during fieldwork in Norway but has also acted as the scientific advisor on this project, editing successive drafts. Roddy McGeoch brought a lawyer's exactitude to the editing process and never failed to correct slack use of language. Richard Luxmoore of The National Trust for Scotland also provided valuable comment on early drafts.

Thanks too to the many biologists and other friends in Scotland, Latvia, Estonia, the Netherlands, Norway and the Czech Republic whose expertise has been freely shared and whose perspective has allowed me to see Scotland's wildlife and wild land in a new light. I am especially grateful to Roy Dennis, Neil McIntyre, Jaanus Järva, Addy de Jongh, Janis Kuze, Torgeir Nygård, Janis Ozolins, Paul Ramsay, Livar Ramvik, Maris Strazds, Toomas Trapido, Kenny Taylor and Ales Toman.

Finally, my thanks to Michelle Mclauglin, whose sterling work in the office lets me to get out into the field.

Principal sources

Corbet, G. & Harris, S. (eds.) The Handbook of British Mammals (Blackwell, 1996)

Cramp, S. (ed.) Handbook of the Birds of Europe, the Middle East and North Africa: The Birds of the Western Palearctic, vols. 1-5 (Oxford University Press, 1977–88)

Lambert, R. (ed.) Species History in Scotland (Scottish Cultural Press, 1998)

Smout, T. C. (ed.) Scotland Since Prehistory (Scottish Cultural Press, 1993)

Yalden, D. The History of British Mammals (Poyser, 1999)

Scottish Conservation Environment News (SCENES) This independent monthly digest of environmental news in Scotland draws upon press reports, informed comment and press releases and reports published by statutory organizations and NGOs. Published by Sue Fenton, details at www.scenes.org.uk/more-content.htm.

Dr Duncan Halley and Dr Richard Luxmoore, in vetting the text, also made contributions from their own research and shared their own perspectives.

World Wide Web

Using information from the web can be fraught with difficulties of validation. Only data and comment posted by recognized institutions, organizations and individuals has been cited, and is corroborated from other sources whenever possible. Amongst these are:

Aberdeen University	www.abdn.ac.uk
British Trust for Ornithology	www.bto.org
Deer Commission for Scotland	www.dcs.gov.uk
Glasgow University	www.glasgow.ac.uk
Joint Nature Conservation Committee	www.jncc.gov.uk
Mammal Society	www.abdn.ac.uk/mammal
Moray Firth Partnership	www.morayfirth-partnership.org
Natural Environment Research Council	www.nerc.ac.uk
Nature scientific journal	www.nature.com
National Trust for Scotland	www.nts.org.uk
OIKOS ecological journal	www.oikos.ekol.lu.se/Oikosjrnl.html
Royal Society for the Protection of Birds	www.rspb.org.uk
Scottish Executive	www.scotland.gov.uk
Scottish Natural Heritage	www.snh.org.uk
United Nation Environment Programme	www.unep.org
UK Biodiversity Action Plan	www.ukbap.org.uk